the digital canvas

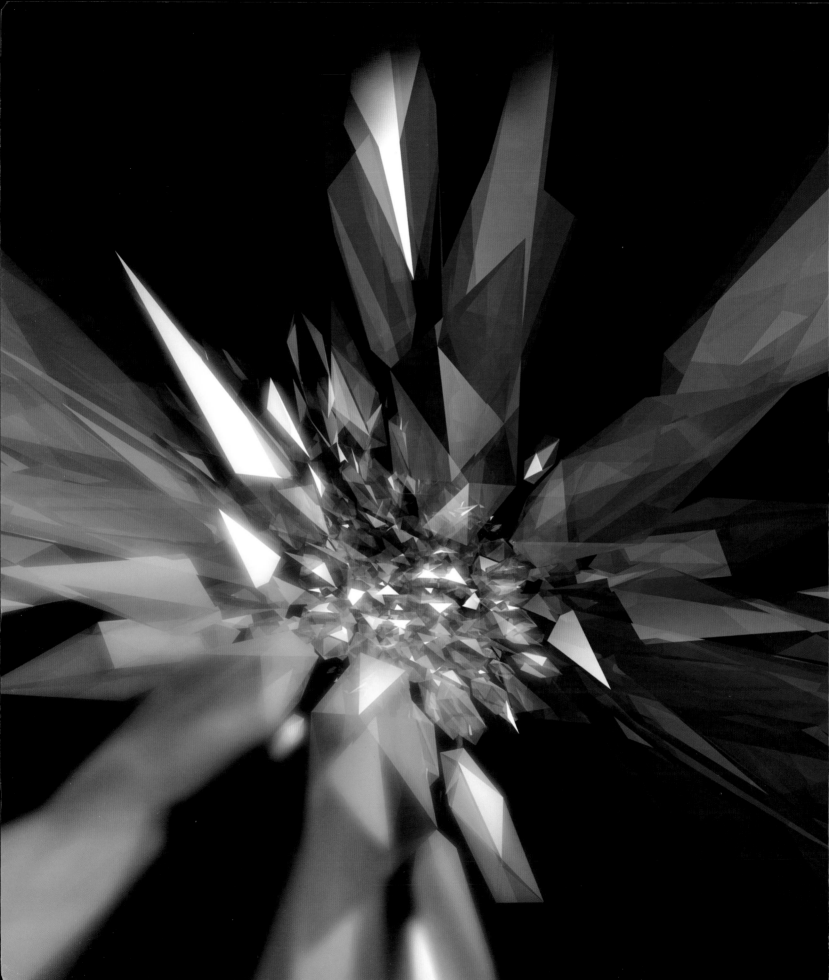

The Digital Canvas

Discovering the Art Studio In Your Computer

Jonathan Raimes

Foreword by Malcolm Garrett

Abrams Studio
Abrams, New York

Book design: Jonathan Raimes
Abrams cover design: Eric J. Diloné

Library of Congress Cataloging-in-Publication Data

Raimes, Jonathan.
 The digital canvas : discovering the art studio in your computer / by Jonathan Raimes.
 p. cm.
 Includes index.
 ISBN 0–8109–9236–1 (pbk. without flaps)
 1. Computer art—Technique I. Title.

 N7433.8.R35 2006
 776—dc22

 2005025958

Printed and bound in China
10 9 8 7 6 5 4 3 2 1

harry n. abrams, inc.
a subsidiary of La Martinière Groupe
115 West 18th Street
New York, NY 10011
www.hnabooks.com

contents

Right: *Before After*—Heaven 17. Pioneers of electronic music in the early 1980s, these Sheffield lads first introduced me to Macintosh computers in 1986. I still work with founder Martyn Ware on many other digital projects, but this is a CD sleeve for the group's most recent recordings. The image is divided into two halves, displaying each in positive and negative, which then play optical tricks with subtle distortion and retinal after-images.

Far Right: *Greatest*—Duran Duran. Working methods were completely transformed in the period between my first designs for Duran Duran in 1981 and this CD package, produced more than 15 years later. Desktop computers now allow me to produce a TV advertisement first, which is then the basis for the sleeve and all other marketing materials. Previously the sleeve itself was always the starting point.

Foreword > Malcolm Garrett

I know what I don't know.

If, as Sir Edmund Hillary suggested, we climb mountains because they are there, then what inspires us to draw, or paint, or indeed to create art of any description? This book may not answer those questions directly, but it is produced with the sole purpose of inspiring us to "paint" in the virtual space that is *The Digital Canvas*, showing even the novice how straightforward yet rewarding it can be.

Just what is inspiration, and where do you find it? With many years' experience to draw on, I still find myself wondering about it, and what an unfathomable yet relentless force it is that continues to drive creative endeavor. I do know for sure that I am a thinker first, and practitioner second, and even now I am still challenged by a certain practical laxity that such a mental attitude implies. I can only produce my best work when the mood takes me, or when the ideas flow. I tend to think twice, and act once. Ideas before industry, always.

I can't tell you where ideas actually come from. They seem to be merely responses to anything (and pretty much everything) that I may see around me. The more I immerse myself in the world, the more I find in it to challenge. I don't quite know why I am always questioning it and the things it presents to me, but I do. There are always questions. And there is no substitute for knowing everything.

Yes, I can be annoyingly contrary, but hopefully in a positive rather than a cynical way. As well as a desire to know everything, I also harbor a secret desire to improve everything, or at least to customize my own version of everything. Yet I don't really think I am a visionary, as has sometimes been suggested, nor do I believe I am particularly ambitious, nor driven, in the accepted sense. I'm no tortured artist. I just do what seems natural to me. And I always have a point of view.

I know that I think "in pictures," and always have. Happily, nowadays I feel more comfortable with doing what seems obvious to me, as I have learned with experience that what is obvious to me is seldom obvious to others, until shown. That's not to say my way is always right, but I am at my best when it is different. "Word games in pictures" was a way I once described my work. I still think it fits. Inherent in it is the implication that the "story" within or surrounding an image has greater value or depth for me than any purely aesthetic consideration. I hope *The Digital Canvas* can demonstrate the benefits of developing a creative discipline for both of these components.

I know also that it is the strange cross-fertilization of unconnected concepts that amuses me. In fact I find most creative thought quite funny, or at least fun, irrational, and irreverent. I'm no purist. I am impressed by the unexpected rather than the norm. My mind flits from idea to concept to shopping list and back again with apparent ease, with occasionally life-affirming, but often somewhat disconcerting, results. Establishing just

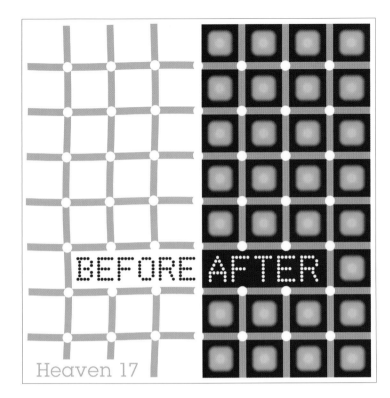

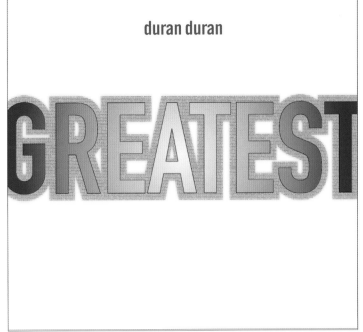

what it is that stimulates me; what prods me into action; what causes thoughts both crazy and mundane (and crazily mundane) to spring into my mind (and always at the oddest moments when I'm doing or thinking of something else entirely); what satisfies me creatively…is all still something of a mystery, if not a conundrum. What is it exactly that, quite literally, keeps me awake at night?

Often visions and visual thoughts pop up almost fully formed, and demand to be put down "on paper" as they are; sometimes they are ghosts of ideas that need massaging and require endless restructuring on the mental drawing board, or in the virtual vision mixer. And yes, I actually do keep that proverbial notebook by my bed. The notebook has an apple on the cover. I have learnt that to get up in the night and make notes (for later) is actually sometimes worth it. Even if they are meaningless in the morning, I know that it was better to have made the effort than not. At the very least, I can then get back to sleep more readily. Frequently, the thoughts are answers to questions, even though most of the time I'm not sure if the questions were mine. I guess that's why I am a graphic designer—the problems I address are so often someone else's. And is it so strange that I tend not to come up with any answers until there are such questions? Also, of course, nothing focuses the mind like an immovable deadline.

So, almost half a century on, I'm still searching, and still dreaming. Actually, I've stopped searching, because I know "it" just happens. One common factor in all this creative deliberation is the exploitation of technology. Any technology. Doing more within the constraints of the medium satisfies something in me. Now, here is a book that addresses just such an ideal. Whether or not your ideas arrive complete and unexpurgated, or if they need to be pushed that extra mile, this book is an exhaustive introduction to the visual and creative opportunities that are open to every user of a contemporary laptop or desktop computer. Creativity has become democratized on the computer desktop in the way that the typewriter, camera, and cell phone democratized other creative and communication endeavors in the past.

I've been working with computers of various flavors since the early 1980s, yet back in about 1985 I still thought I was a late starter. I spent what seemed like an endless period of time considering rather than participating in the revolution still to come. I was not a programmer and the "wysiwyg" and "wimp" interfaces that were eventually to make these boxes useful in the everyday world were still some years away, still waiting to be let loose from the garages of Cupertino. In retrospect, I was of course an early convert, and as software developed so did my comprehension of the vista opening before me. The war cry "The book is dead?!," prompted by an unbridled enthusiasm for digital media, still resonates fifteen years on from when I, allegedly, first said it.

The Digital Canvas embraces this most contemporary of artforms. There is already a wide range of work from an increasing number of artists, designers, and studios that makes this field a very "now" subject.

Right: These posters were produced to accompany the publication of a typeface I had designed for Neville Brody's *Fuse* magazine. This was the first issue of the publication, distributed on floppy disc, which went on to feature experimental type designs by new designers from around the world.

The typeface, called Stealth, was based on an earlier logotype for a shop, and used a grid structure of concentric circles and squares to define each character. The font was later published commercially by Berlin-based FontShop.

The origins of "Computer Art" (as it used to be known), however, go back at least as far as the 1960s. Ground-breaking works were shown in 1968 at the Institute of Contemporary Arts (ICA) in London, at the "Cybernetic Serendipity" exhibition, and later, in 1985, even Andy Warhol made early, tentative experiments into video image manipulation with the Commodore computer. Acknowledging the groundwork and experimentation of a broad spectrum of pioneers, who have often struggled to produce images with complex and unwieldy hardware, already brings a rich and varied heritage to digital art. They have established it as a legitimate and inspiring creative medium, despite (or possibly because of) the ongoing issues of definition and acceptance that this new medium has posed for the art world.

The Digital Canvas is certainly not intended as an academic study of digital art in any formal, historical, or critical sense, but is instead an exploration of this relatively new and exciting field from a decidedly practical viewpoint. That said, just as those who ignore history are condemned to repeat it, maybe those who simply repeat history without addressing the implications for the future are also to be condemned. History is not bunk! Believe in the future! *The Digital Canvas* is not attempting to be just a manual of "how to" use software, or "how to" be an artist, although it embraces aspects of both. This is also not for dummies! Hopefully, it seeks not to paper over "old" art with a newer style, nor to just give it a fresh coat of paint. It is simply, beautifully,

and practically a broad-reaching and thorough examination of an ever-developing creative medium, and is intended to stretch the imagination and inspire. Above all, it is a book of possibilities.

Over the last five to ten years, home computing power has escalated to a remarkable level, and accessible software tools have become ever more sophisticated in parallel. The ability to generate and manipulate imagery and digital "art" to what could be considered a "professional" level has effectively become available to anyone. This, then, is a book for those with some level of experience and expertise within the digital medium, as well as for raw beginners. It suggests starting points. It also questions boundaries. It prompts direct intervention. The overlap between art, information, games, and entertainment is already blurred. *The Digital Canvas* offers some insight into the "how," and thereby also makes some sense of the "why" of digital art. It is an easy-to-follow, practical guide to how straightforward it is to source original material, to sketch out ideas, to compose and develop images and artworks, to exploit software, and then to go on to produce, publish, and distribute your own digital works.

The Digital Canvas serves fundamentally as an introduction to ways of generating original imagery in a digital space. It is a practical resumé of the kind of basic, easy to acquire, easy to use digital hardware that is readily available to all potential digital artists. With a useful introduction to contemporary computers, examining the different

Right: *Love You More / Noise Annoys*—
Buzzcocks.
One of my earliest record sleeves,
produced many years before computers
found their way into the design studio,
but clearly displaying the kind of
technical illustration style that has always
fascinated me. Each image relates
directly to the song and makes visual
reference to its counterpart on the other
side of the sleeve. "Love You More" deals
with loneliness and despair, while "Noise
Annoys" is obviously quite the opposite.

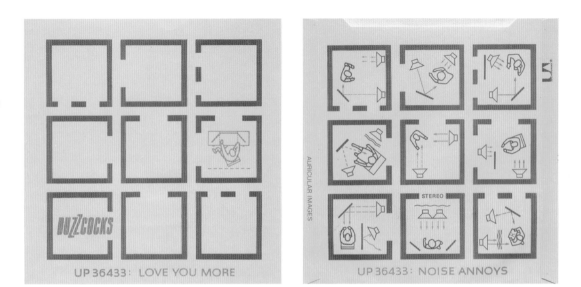

types of hardware you will need to get started and the workings of each component from a creative standpoint, it prompts discussion and exploration of how these various pieces can interact and how they can best be put to work. All art is determined by the technology of the day. The better grasp the artist has of the workings of the tools at his or her disposal, the better able he or she is able to exploit their characteristics and push creative boundaries.

The same is as true for software as it is for the hardware that you can physically hold, albeit in a less direct way. Results can often be harder to visualize, or to master, but understanding the very nature of the digital environment will help ensure that works are exploring genuinely new possibilities made available in the digital world, rather than aimlessly replicating the products of other, older media.

Ultimately, all digital images can be "described" as a set of instructions to "paint" shape and color onto a screen, or to electronically transfer ink onto paper. It follows that it is therefore possible to bypass the need for any kind of conventional dexterity and simply scan or "sample" existing objects or images to modify and combine with others in exciting ways. Alternatively, it is possible to use a keyboard and type instructions that the computer and software will understand in order to generate images directly from written parameters. Ironically, the keyboard, which is conventionally the way most people have been first encouraged to approach making the computer work, is arguably the

least obvious way to create imagery. No creative avenue is ignored, and *The Digital Canvas* is methodical in its exploration of painting with pixels and vectors—creating with line, shape, and color; and modifying and distorting form and language.

The Digital Canvas is anything but a canvas in the conventional sense—it is a fluid, hard-to-define virtual medium. Pocket digital cameras, hi-definition digital video, networked systems (local, global, and wireless), large-format flat screen technology, handheld devices of all kinds (cell phones, games consoles, and PDAs), BlueTooth, IRD tagging, and GPS positioning, are just some of the ongoing technical innovations that are opening up yet more fresh challenges for the digital artist. Exploring the world beyond one's own computer monitor, while arguably a little beyond the scope of this book, suggests an ongoing dialog that will take your creative work beyond painting by digits, and help to ensure its use-by date is extended as far as possible into the future.

I know that Inspiration never sleeps. And paint never dries on *The Digital Canvas*.

Malcolm Garrett RDI, 2005

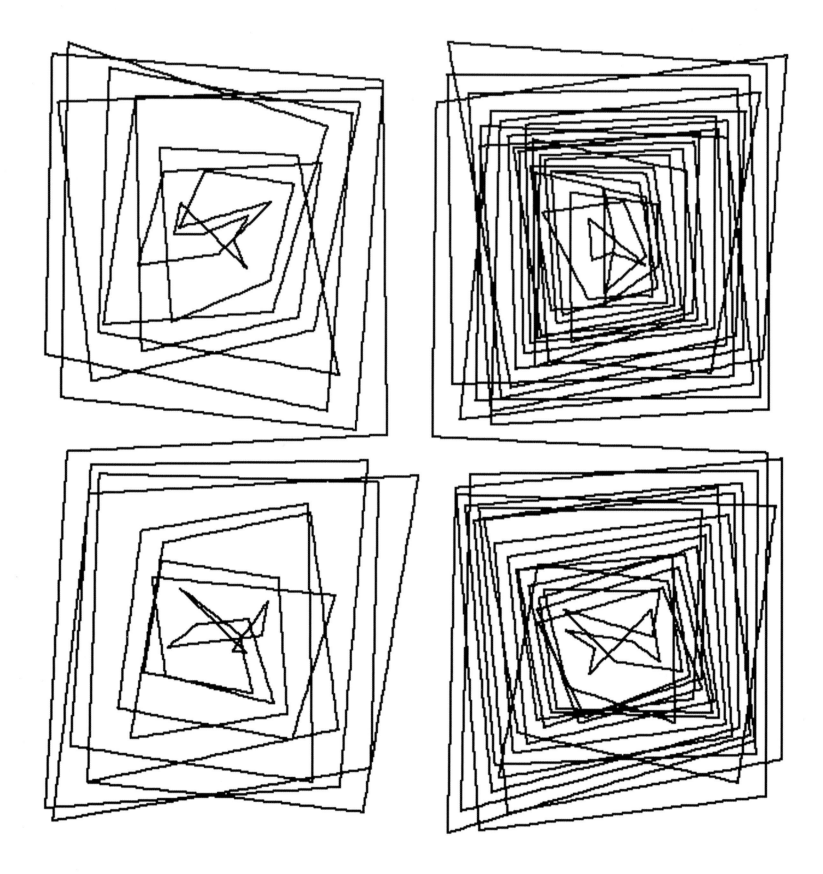

Left: Image inspired by the work of the artist Vera Molnar, born in 1924. Molnar started experimenting with the computer in 1968. Her initial work involved the transformation of geometric objects, such as squares, by rotating, deforming, or erasing all or parts of them, or replacing portions with basic elements of other geometric shapes. She would often repeat the primitive geometric forms while fracturing or breaking them as she transformed them, ultimately outputting the results to a plotter.

Art and the computer > **A brief history**

By the mid-1960s the world was waking up to the possibilities of an age in which computers might play a significant role in the way we live. As awareness grew, artists tentatively began to explore the emerging computing technology for use as a creative tool.

Up to this point, most individuals involved in the creation of computer art had been engineers, mathematicians, and scientists. The only computing resources that had been available were massive mainframe machines installed at industrial and university scientific research labs, and the only people who had access to them were from the scientific community. The programming language was a mystery to the average mortal—real interactive software had yet to be developed. More fundamentally, the process of creating art on the computer was algorithmic in nature, contrary to the way traditional artists were used to thinking.

In those early days, these scientists and mathematicians promoted themselves as artists. Dr. A. Michael Noll, an early pioneer in the use of computers in the visual arts, spent nearly fifteen years performing research at Bell Telephone Laboratories in Murray Hill, New Jersey, beginning in 1961. His computer-generated patterns simulating paintings by Piet Mondrian and Bridget Riley have become classics. The first two exhibitions of computer art, both held in 1965–Computer-Generated Pictures at the Howard Wise Gallery in New York, and Generative Computergrafik at the Technische Hochschule in Stuttgart, Germany–featured work by Dr. Noll and other scientists. They were important events in the establishment of computer art as a recognized and (eventually) accepted art form.

In 1967, artist Robert Rauschenberg and engineer Billy Kluver, together with Robert Whitman and Fred Waldhauer, founded an organization known as the E.A.T., or Experiments in Art and Technology. The aim was to "develop an effective collaboration between the artist and the engineer." Though not strictly computer based, the movement was supported by leading artists of the day such as Andy Warhol, John Cage, and Jasper Johns, and encouraged the use of technology in the visual and performing arts.

Another visionary artist, Stan Vanderbeek, embraced the new technologies of film, video, and computers. As an artist-in-residence and instructor at the Massachusetts Institute of

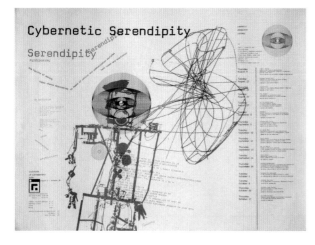

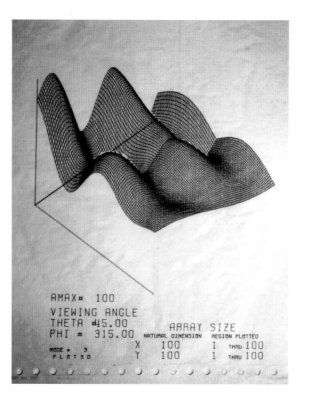

Technology (MIT), Vanderbeek created early computer art in an effort to get as close as possible to the functioning of the human nervous system: "For the artist, moving into the area of computers is extending his mind with a tool technically as responsive as himself. Technology becomes the amplifier for the human imagination."

In 1968, the Institute of Contemporary Arts (ICA) in London hosted one of the most influential early exhibitions of computer art–Cybernetic Serendipity–which is acknowledged as a milestone in the recognition of the new medium. Curated by Jasia Reichardt, the exhibition included most of the important contributors to the world of technology-driven art at the time– Dr. Michael Noll, Nam June Paik, Frieder Nake, John Whitney, and Charles Csuri, often regarded as the first true "digital artist."

Needless to say, there was resistance to accepting a technological approach to creativity–a substantial portion of the art world, both practitioners and critics, regarded the "trial-and-error" approach employed when using a machine as part of the creative process to be contrary to the artistic ethos, which historically relied on self-discipline.

In December 1985, mainstream artists including David Hockney and Larry Rivers were commissioned to demonstrate the Quantel Paintbox, a computer system that had been developed for logo and special effects work in the television broadcasting industry and allowed the artist to sketch onto the monitor screen using a digital tablet. In 1986 Hockney's works were so successful that a video was made while he was using the Quantel, and broadcast by the British Broadcasting Corporation (BBC). In the same year, Andy Warhol made a series of works with the Commodore Amiga, including self-portraits and portraits of singer Deborah Harry.

Throughout the '70s and '80s the development of computer technology accelerated. Computers became smaller and more powerful. By the end of the 1980s, the desktop computer started to take the business world by storm, and as the price of components decreased, mass production increased. In turn, unit prices dropped, and it wasn't long before there was an explosion in usage in the home and education markets.

The first Graphical User Interface (GUI) was designed by Xerox Corporation's Palo Alto Research Center (PARC) in the 1970s, but it was not until the 1980s and the emergence of the Apple

Far left: Poster advertising the *Cybernetic Serendipity* exhibition at the Institute of Contemporary Arts (ICA), London, in 1968.

Left: *Sculpture Graphic/Three Dimensional Surface*—Charles Csuri 1968. Work created using mathematical principles to define the surface of a form. Using the computer, Csuri was able to experiment with elevations and the frequency of the curvature. Computer plotter drawings were made for viewing the results, as there were no monitors at the time. The computer program then generated a punched tape to represent the coordinate data. Included were instructions to a 3-axis, continuous path, numerically controlled milling machine which cut a three dimensional sculpture from a block of wood.

Right: *Sine Landscape*—Charles Csuri 1967. "I made a line drawing of a landscape that was then digitized as input. A sine wave function was used to make modifications to the drawing."

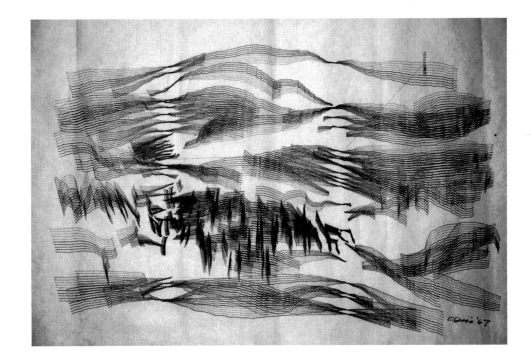

Macintosh that the GUI became popular. The fact that Apple based their interface on the Xerox original is not widely known. The GUI made the computer far less daunting to anyone with a visual mind–giving birth to a "user friendly" experience. Creatives soon started to realize the potential of the machine. Early exponents of the technology were graphic designers, who quickly and wholeheartedly accepted its capacity as a creative tool. Random concepts and ideas could be committed to the machine's memory in no particular order and called up when needed, "cut and paste" was born.

It was not only the limited processing power, expense, or sheer size of the computer that restricted its early use as a creative tool, but also the technology available to output or print the results. Early machines used pen-and-ink plotters that provided only the most basic "hard copy." As the computer developed, so did the printer.

The dot matrix printer, introduced in the '70s, used a print head that ran back and forth on the page printing by impact, striking an ink-soaked cloth ribbon against the paper, much like a typewriter. Letters were drawn out of a "dot matrix," enabling the reproduction of varied fonts and arbitrary graphics. During the 1970s and 1980s dot matrix printers were generally considered the best combination of affordability and versatility, and until the introduction of the inkjet they were by far the most common form of printer used with personal computers.

The inkjet printer was invented in 1976, but it took another twelve years for it to become available to the public, when Hewlett-Packard released the DeskJet. This carried the huge price tag of $1000 in 1988. The first laser printer, called EARS, was developed at the Xerox Palo Alto Research Center, and completed in 1971. Hewlett-Packard and Apple, however, were the front runners in bringing laser printing technology to the market, introducing the HP LaserJet printer in 1984, and the Apple LaserWriter in 1985. Affordable color printing technology was not available until the mid-1990s, and it was at this point that the artistic community really sat up and took notice of the computer's potential.

With the development of the hardware and the emerging operating systems came the necessary revolution in software development. User friendly programming made it possible for

Left: In the late 1980s, Thomas Knoll, the son of an avid photographer who was familiar with darkroom techniques, began to program image processing routines on the Mac. Together with his brother John, who was working at George Lucas' Industrial Light and Magic, they created an image editing program, eventually named Photoshop, which they sold to Adobe. It was released as a commercial product in 1990, and remains the most widely used professional color graphics software to this day.

Right: The development of vector-based drawing programs, such as Adobe's Illustrator, provided artists with a blank canvas on which they could build up drawings from colored shapes and lines.

anyone to make use of the computer's processing potential, without having any idea of what actually went on "behind the scenes." As the hardware engineers squeezed more speed out of the processors, the applications became ever more powerful. The graphic capabilities of the computer seemed boundless, and an industry was established to create the software to exploit it.

Drawing, painting, and image manipulation software became "must haves" when purchasing the new machines, taking their place alongside the word processing and spreadsheet applications. Apple was quick to realize this potential and the software developers embraced the Macintosh interface wholeheartedly. Adobe, founded in 1982 to develop the PostScript language and digital fonts, was ahead of the game. They introduced Illustrator, a vector drawing program based on the Bézier curve, in 1987, and Photoshop (now the industry standard image-manipulation application), written by brothers Thomas and John Knoll, in 1990. Both were written solely for use on the Mac.

Of course, at this time the only affordable computer monitors were grayscale and low resolution. Adobe played an important

role in pushing for the development of larger, sharper, and eventually color screens which could take full advantage of their creative products. Understandably, the Macintosh was the tool of choice for the creative community. It was not until the mid-'90s and Microsoft's more palatable Windows 95 interface that the major players in the creative software industry turned their attention to the mass market of the PC.

Other developers introduced applications aimed specifically at the creative and artistic user. Corel's Painter and Deneba's Canvas programs mimic traditional art techniques using wet and dry brushes, pencils, and pens in conjunction with simulated canvas and paper surfaces. Drawing applications were created to cater for every age group, making "creative play" on the computer possible even for young children. For those who have grown up during the technology boom, accepting the computer as a source of creativity is second nature.

The 1990s heralded the dawn of the age of the Internet. The general public gained access to an astonishing world of information and imagery, and the technology exploded over the course of the decade. Here was visual stimulation on a

massive scale. The Internet created opportunities for smaller developers to offer a multitude of different creative aids. Ideas and advice could be freely shared, and artistic work showcased to the world. As the act of communication through the Internet became commonplace, people inevitably spent more time using the computer and became accustomed to viewing imagery on screen. The creative use of pictures and type by web designers and graphic artists could be appreciated by everyone, every day. Inspiration is truly at our fingertips.

So now, equipped with astonishing levels of processing power in tiny boxes, screens that display billions of colors, and accurate high-resolution printers capable of producing photographic quality, all at an affordable price, it is possible for anyone to become a digital artist.

This book is not intended to act as a comprehensive guide to using proprietary software. The effects and techniques employed to create the images in *The Digital Canvas* are common to most of the bitmap- and vector-based painting and drawing applications on the market. Basic drawing software comes as standard with both major operating systems–Paint

for Windows and AppleWorks on the Mac. Both packages offer similar tools and enough scope for the budding artist to get started. Photoshop Elements, an abbreviated version of the full application, often comes as part of a bundle when purchasing a scanner, or free thirty-day tryout versions can be downloaded from the Internet. If you are using a computer, then you already have the basic skills required.

Experimentation is the key. Allow the machine to work with you, rather than for you. The aim of *The Digital Canvas* is to provide inspiration, not to show you how to use a computer to execute the perfect representation of an idea or create a technically accurate illustration, but to encourage you to be adventurous. Let the technology take you on a creative journey–you may not know the destination until you reach it.

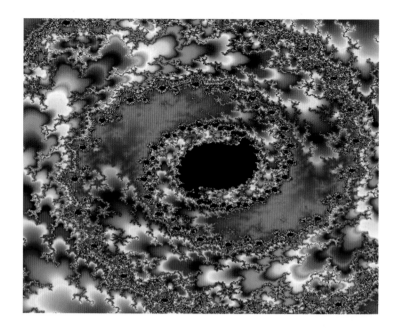

Art and the computer > **Fractals**

The original, and most instantly recognizable "psychedelic" computer art is the fractal. A fractal is an image that exhibits self-similarity; in other words, it is built using reduced versions of itself. Fractal geometry is a language used to describe, model, and analyze the complex forms found in nature. Conceived by Benoit B. Mandelbrot, the amazingly complex and sometimes very beautiful imagery is efficiently generated by the computer using mathematical formulae.

The chaotic patterns of fractals can be found in many branches of science: physicists find them on their plotters, biologists diagnose dynamical diseases. Fractals provide a different way of observing, modeling and occasionally challenging complex mathematical theories like Euclidean Geometry or Calculus. Though not strictly within the remit of this book, fractals remain a popular digital art form—they even win prizes at graphics shows and appear on T-shirts and calendars. And you don't have to be a scientist to create them—the amateur computer user can have fun creating these wild images on one of the many web-based fractal generators.

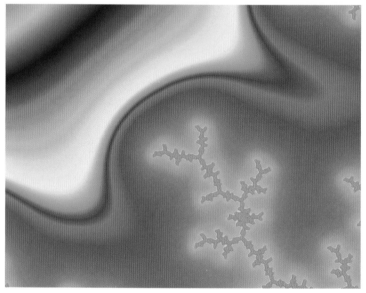

Top: A Mandelbrot fractal, formed using one the many fractal generators available on the Internet. Simply enter the desired parameters and the image is automatically created.

Above: Another example of a Mandelbrot fractal. The self-similar nature of fractals means that continuously zooming in on a portion of a fractal will eventually reveal the same pattern.

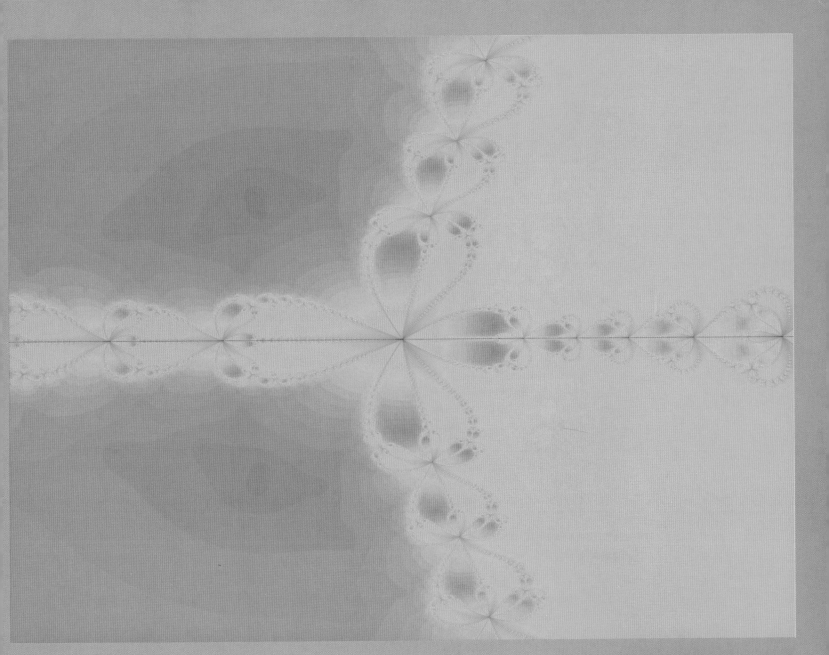

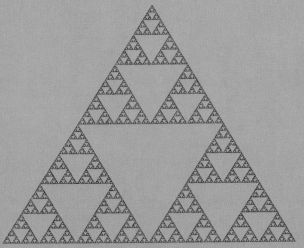

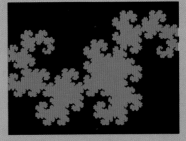

Left: The defining property of fractals is self-similarity, or the repetition of patterns at all scales. This is a Sierpinski triangle—a classic example of fractal structure. Each triangle is split into four similar triangles, and the center triangle is removed.

Above: Another historically important image is the "Koch Snowflake." Unlike Mandelbrot sets, this fractal has true similarity. Each side is made of small sections of the whole, though the entire fractal is never repeated.

Multiple duplication of the artist's hand. One of a series of illustrations commissioned by *Cartier* magazine.

Masters of the art > John Maeda

John Maeda is a world-renowned graphic designer, artist, and computer scientist at the MIT Media Laboratory. He has pioneered the use of the computer for people of all ages and skills to create art, and is currently spearheading a new research initiative to "redesign technology" so that it consistently makes sense, is fun, and keeps us coming back for more. Maeda holds the E. Rudge and Nancy Allen Professorship of Media Arts and Sciences, is director of the MIT lab's design-oriented Physical Language Workshop, and codirects SIMPLICITY, a research program aimed at redefining users' relationships with technology in their daily lives.

Maeda's early work redefined the use of electronic media as a tool for expression by combining skilled computer programming with a sensitivity to traditional artistic concerns. This work helped to pioneer the interactive motion graphics that are prevalent on the Internet today. He also initiated the Design By Numbers project, a global initiative to teach computer programming to visual artists through a freely available, custom software system that he designed. He has displayed his work at numerous exhibitions, lectured extensively worldwide, and published several books featuring his graphic designs.

"The computer is a multidimensional canvas, manifested as projected light or a printed surface, over which we can exercise complete expressive control in one of two ways. First, through some direct physical means, such as hand-to-mouse, where there is a one-to-one correspondence between our gestures and change on the canvas. This approach is closest to the traditional process of visual expression—applying pigment to paper through physical interaction with the medium—and is thus the most natural of means. On the other hand, there is the decidedly non-physical means of expression called computation, where a computer program, defined by a programmer/artist, explicitly instructs the canvas on where and how to apply virtual pigments to itself. The artist makes no physical contact with the medium, aside from the process of inscribing the program instructions onto the computer.

"In my research, I actively seek to bridge the gap between computational and non-computational expression by designing print-based work which illustrates a sensitivity to the past while embracing the future. However, I also continue to push the envelope of expression with work created solely for the digital medium."

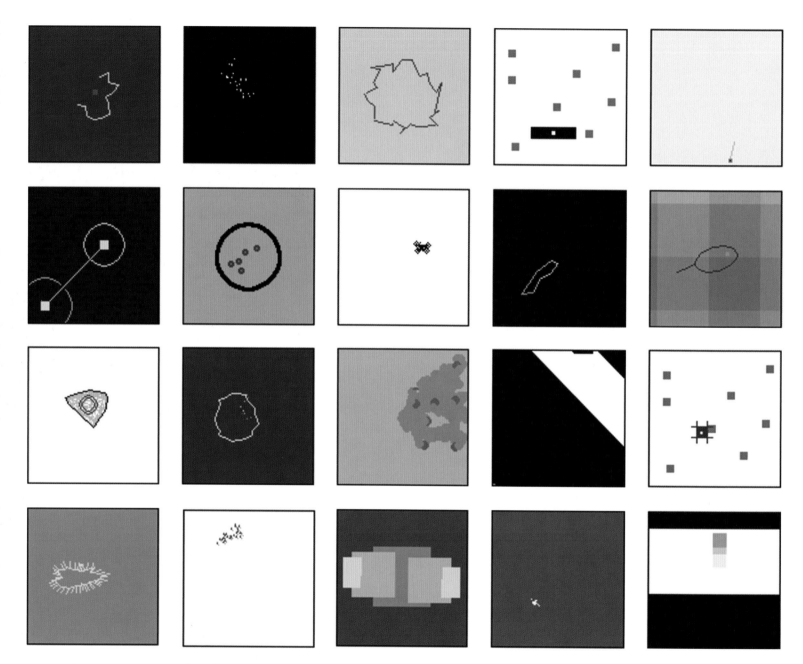

Above: **Screenshots taken from animated images created by Design By Numbers, a program written by Maeda to give students an understanding of the code that forms the basis of all computer programming. The position and color of each pixel is entered as a coordinate in the 100-pixel grid. The constantly changing images develop on screen as the program runs.**

Opposite: *Florada (2003),* **created for the UCLA Extension School Catalog cover for Spring 2004.**

Part 1

start here >

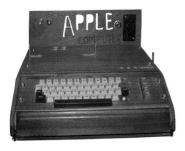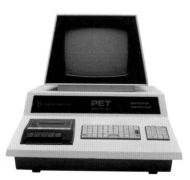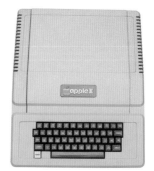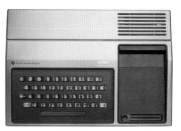

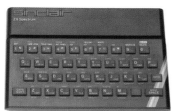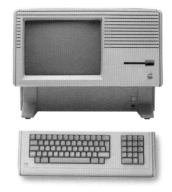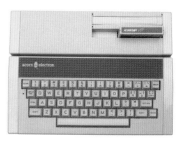
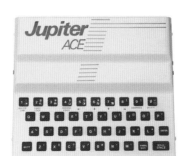

Above: **The evolution of the microcomputer. The first computers came with a handful of kilobytes of memory and an extremely limited color palette.**

Opposite: **The ultimate machine for the serious graphic artist, the Power Mac G5.**

1.1

What you need > **Hardware**

Assuming you have not spent the last thirty years living on a desert island, you are reading this book because you already have a computer and are interested in getting more out of it than word processing and e-mail. In case you have yet to make a purchase, or you are thinking of upgrading an ancient monster, here are some points worth considering.

Be aware that machine types fall into two basic categories, PC and Mac. Macs have traditionally been the standard choice for professional graphic users, though today there is little real difference between the two camps. Much of the standard graphics software runs on both platforms, and their abilities–and cost–are broadly similar. The choice nowadays is one of personal preference, unless there is a specific piece of software or task for which you require the machine.

If you are serious about using your computer as a creative tool, then two important factors, processing speed and memory, must be taken into account. The processor is the "brain" of the machine, and the speed with which it makes the billions of calculations necessary each time you tell it to perform a function will determine how fluently you can work. Processing speed is measured in gigahertz, and the latest machines can clock up between 2 and 3 GHz. This rating only acts as a guide; the technology behind a G4 or G5 processor in a Mac is vastly different to an Intel Pentium in a PC. The processor speed of a PC may be greater, but because of the different architecture, this may not result in a faster machine overall.

Graphic applications are complex, and performing what may appear to be a simple task takes a huge amount of computing power. Working in color on a high resolution file requires a large amount of Random Access Memory (RAM). This is the short term memory the processor uses to access information. To store the finished files permanently, the computer uses a mechanical device, the hard drive. When you save your work you are copying it from the RAM to the hard drive.

The size of those final files may be large in digital terms, so the greater the hard drive capacity, the better. A word processing document may consist of around 30,000 bytes, whereas a print resolution graphic file of the same physical dimensions would be 25 million bytes. Modern hard drives generally come as standard in 40 or 80GB variations (1 gigabyte is a thousand million bytes).

Most modern machines are supplied with a built-in "graphics card" that helps drive the screen display. In computer gaming, the graphics card makes the difference between an exciting gaming experience and the tedious redrawing of pixels on the screen. The same applies to graphic files; you don't want a frustrating delay each time the screen refreshes.

What you need > **The monitor**

Visual art is expression, seeing, and perceiving. To be in a position to make a visual statement, the digital artist must have the best possible means of viewing his work. Imagine what it must have been like for early technicians, trying to create images with code without the use of a monitor. Both the physical size and the resolution (the number of pixels the screen is capable of displaying) of the monitor you use will play a significant role in your creative venture.

Ideally, to work on an image effectively you need to see the whole picture on screen as close to the final reproduction size as possible. This would not be such an issue if you only ever wanted to view your work on screen and never print it. To create a successful print, you must work at a reasonably high resolution–300dpi (dots per inch) is the recognized minimum. The larger the screen, the less time you will need to spend zooming in and out to view the finer details of your artwork.

It's not just your artwork that is going to fight for screen space. Painting and drawing applications use a multitude of tool bars and palettes to display the various controls. Though you can open and close them as required, this is not a convenient or practical way of working. It's far better to keep them permanently open on the desktop, alongside rather than on top of your work.

Left: Apple monitor, wireless keyboard and mouse.

Right: The Wacom Cintiq combines a monitor with a graphics tablet to create the ultimate input device for creatives. You literally draw directly onto the screen.

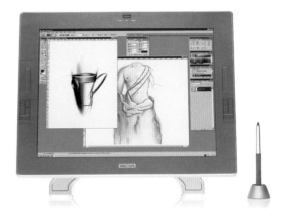

What you need > Input devices

The traditional **CRT** (cathode ray tube) monitor is rapidly being superseded by **LCD** (liquid crystal display, commonly known as "flat screen") technology. LCD monitors can be manufactured in much larger screen sizes than the bulky CRT, and in the past they have been far more expensive. Now, as with all new technology, the increased demand is driving prices down.

Monitor color calibration is important when creating graphics files. What you see on screen in **RGB** will not necessarily be what you see on the final **CMYK** printed result (see pages 50–51 for more on RGB and CMYK). Digital color correction is a vast and complicated subject, but if you are serious about using your computer as a creative tool, then it's worth taking the time to do some research. To make life simpler, your operating system has built-in calibration software, and monitors purchased separately will be supplied with color profiles. Follow the manufacturer's guidelines (usually provided as a "wizard" or workthrough) to adjust the color temperature, gamma, or brightness and contrast settings.

The keyboard and mouse that came packaged with your computer will be enough to get you started in the world of digital art. The instructions, or code, the computer requires to perform any task, including creating digital images, can be entered using a keyboard. A software programmer used a keyboard to input all the instructions that allow you to paint shapes, lines, and color on your computer. Other than typing text, you can use the keyboard to provide keystroke shortcuts when using the graphics software, to vastly speed up the creative process.

The universally accepted input tool is the far more user friendly mouse. Though it can be an unwieldy drawing implement (some might say it's like trying to paint with a brick!), with practice you will find the mouse can be a flexible and effective tool. The latest optical mice use light to plot the position, rather than the wheels, rollers, and rubber balls of the previous generation, and are fast and accurate. Wireless connections now allow even more freedom of movement.

A graphics tablet and electronic stylus reflect a more traditional way of working. The conventional skills of the artist or draftsman can be drawn upon directly, using the pen to perform delicate and precise movements to create controllable, electronic ink and paint. The latest "tablets" are actually monitors; you literally draw onto the screen.

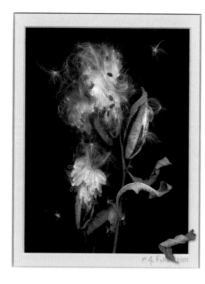

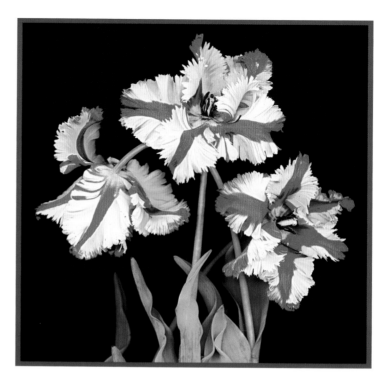

Input devices > Scanners

When you use a scanner to input an image to your computer, you are effectively taking a digital photograph. You can input two types of image: reflective (anything that you view by shining a light on it, and that can be placed on the glass scanning plate, including "hard copy" or solid objects); and transmissive (anything you view by shining a light through it, such as photographic transparencies or overhead projection acetates). Both modes are creative assets to the digital artist.

Any desktop or "flatbed" scanner can be used to input images, though be aware that the cheaper models may not have the option to scan transmissively, or may only allow you to scan 35mm transparencies.

A scan is made not by taking an instant snapshot, but by a gradual build-up of information received by the scanning head as it passes over the target, line-by-line. The mechanical performance is almost as important as the optical.

You don't necessarily need a machine that is capable of scanning at super-high resolution if you are not trying to create reproduction-quality photographic images. However, the resolution (the number of captured pixels), dynamic range (how well the scanner deals with contrast, highlight, and shadow details), and bit-depth (how the scanner captures color information) will inevitably affect your results.

Above: *Psychedelic Tulips* by Patri Feher.

Above Left: *Autumn Explosion* by Patri Feher.

Both images were created by placing real objects directly onto a standard flatbed scanner. Color adjustments to the images were all carried out with the scanner hardware.

In simple terms, the more information the scanner can digitally generate, the more creative scope you have to manipulate or "play" with the image; and the more expensive the machine, the better quality the scan it can produce.

The scanner will be supplied with software that will enable you to control the input settings, including resolution, color, and contrast, and also the final size of the scanned image. If you want to use the scanner as a creative tool, experimentation will be called for when setting the controls, depending on the subject to be scanned. More often than not, you won't know how successful a scanned image will be until you see the result on screen.

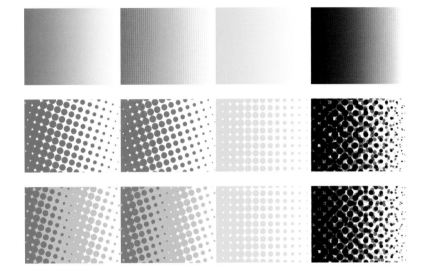

Right: Three different methods of printing color. The first, continuous tone, is the ultimate—perfect graduated tints without any spottiness or banding. Unfortunately, most technologies don't allow high-quality tones such as these. The second set represents standard CMYK halftones. The third set shows a six-color process where lighter cyan and magenta inks are used to eliminate the spottiness sometimes apparent in CMYK printing.

What you need > Output devices

An inkjet printer is the cheapest and most versatile option for everyday digital color output. Printers available for around fifty dollars can produce amazingly defined and accurately colorful results, though the size of the print may be restricted. While the standard "letter" size may suffice for business use, the digital artist will often want to work on a larger scale. Larger output formats require a greater investment, though they are becoming cheaper year by year.

Mass-produced, low-cost inkjet printers are designed to turn out crowd-pleasing results, often oversaturating colors and sacrificing accuracy as they do so. If color fidelity is an important factor in your work, then you will need to move on to a higher price bracket. ICC-managed color machines have revolutionized the "proofing" process—the task of producing printed output that simulates what will appear on press, without having to run the press itself to produce an expensive "wet proof."

Until recently, accurate color proofs could only be generated using film-based chemical transfer systems with brand names such as Cromalin and Matchprint. Desktop inkjets can now produce acceptable results for a fraction of the price, partly thanks to the latest six-ink processes.

To achieve the best quality output, you require a RIP either built into the printer or supplied as a software package for your computer. Raster Image Processing is the process of turning vector digital information, such as a PostScript file, into a high-resolution raster (bitmap) image. In other words, the RIP takes the digital information about fonts and graphics that describes the appearance of your file and translates it into an image composed of individual dots that the imaging device (such as your desktop printer) can output. Basic inkjet devices don't have a RIP, and can't interpret PostScript, relying on your graphics software to rasterize images.

Other affordable output technologies include laser, solid ink, and dye sublimation printing. Though more expensive than inkjets, the cost of desktop color laser printers is falling rapidly. Traditionally chosen for speed rather than image quality, the latest technology produces excellent results. Solid ink printers, available almost exclusively under the Tektronix brand from Xerox, squirt liquefied wax onto the paper to build up an image; although they can cope with a wider range of paper types, they are not as popular as inkjets.

Dye sublimation printing works by vaporizing ink, rather than squirting it in dots, onto the page, giving better ink coverage and none of the "spottiness" seen with inkjet printers. This system is used commercially to produce images from dedicated photo printers, which plug directly into digital cameras.

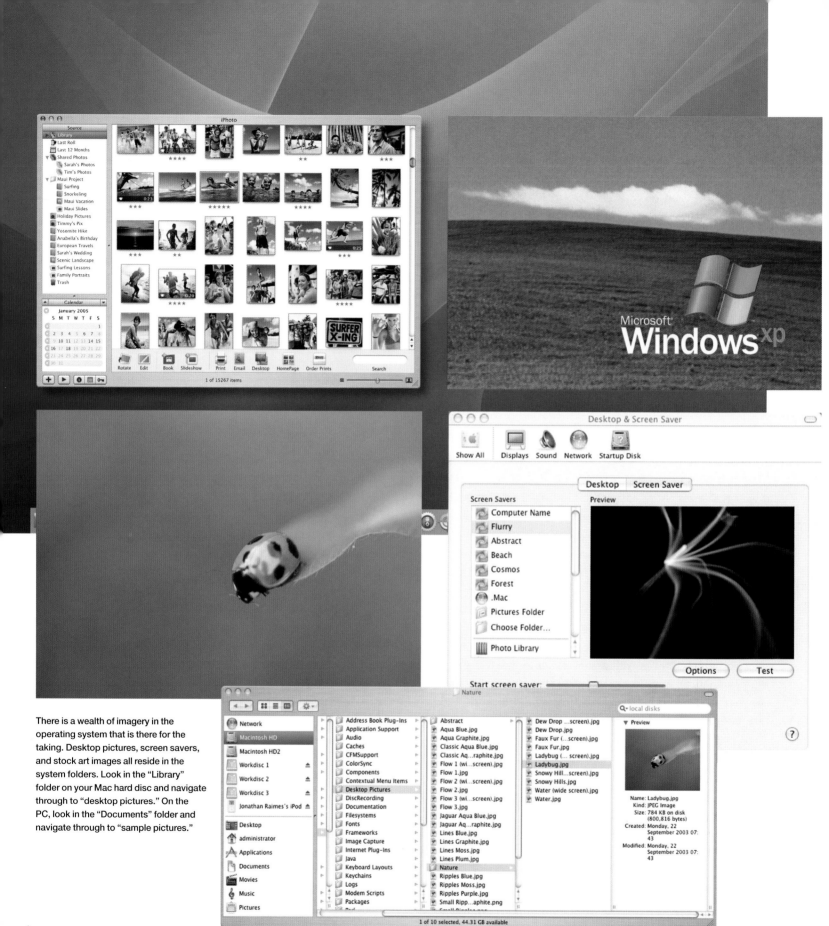

There is a wealth of imagery in the operating system that is there for the taking. Desktop pictures, screen savers, and stock art images all reside in the system folders. Look in the "Library" folder on your Mac hard disc and navigate through to "desktop pictures." On the PC, look in the "Documents" folder and navigate through to "sample pictures."

The icons built into the latest operating systems and applications are very sophisticated. A larger version of the application icons in Mac OS X can be opened by selecting the icon and going to File > Info.

1.2

What you can use > **The interface**

People recognize graphic representations faster than they read words or phrases. A well-designed Graphical User Interface (GUI) frees the user from learning complex command languages, taking advantage of the computer's graphics capabilities to make the machine easier to use. It interacts with the user by way of icons that represent programs or features. After early development at Xerox, the Apple Macintosh was the first system to use a GUI; Microsoft, realizing the potential, followed suit with Windows.

In addition to this useful visual shorthand, the Graphical User Interface also makes it easier to move data from one application to another. The GUI includes standard formats for representing text and graphics, and because the formats are well-defined, different programs that run under a common GUI can share data. This makes it possible, for example, to copy a graph created by a spreadsheet program into a document created by a word processor.

All the visual elements that make up the GUI–its pull-down menus, dialog boxes, check boxes, radio buttons, drop-down list boxes, scroll bars, scroll boxes, and, of course, icons can be utilized in your own creative digital art. Bear in mind, though, that these images and icons are the copyright of the operating system creator (for example, Apple or Microsoft), so should not be used for commercial works. Many applications also include stock art or "clip-art" illustrations–again, check for copyright or usage permissions before incorporating them into your artwork.

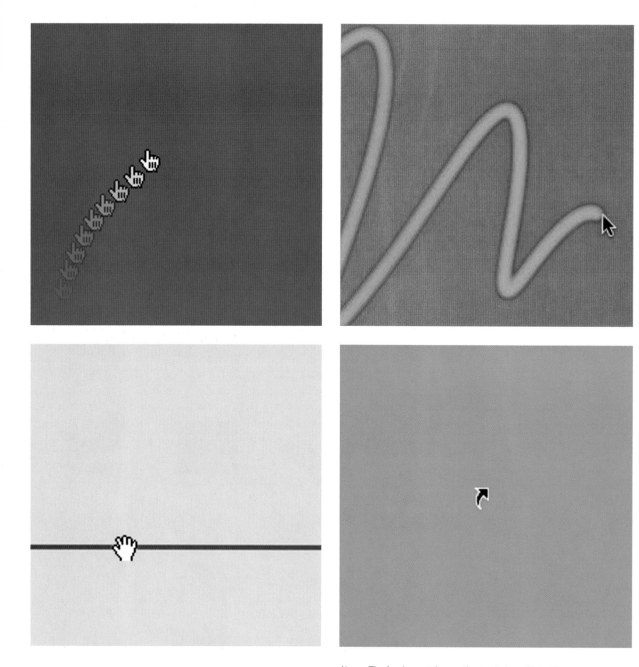

Above: The fundamental operating tool of a GUI is the cursor, which is represented in different forms in different screen environments and software applications. Cursor actions provide the direct link between the user and the machine, and can provide some unusual visual effects. The cursor is your digital pen, pencil, or brush, with which you make the marks on the screen or "digital canvas."

Right: The symbols and letters of computer code itself, the backbone of digital technology, can be put to creative use—the HTML source code, for instance, available to view in any web page—can be copied, pasted and colored to represent a visual form of "concrete poetry."

```html
<title>Zadlers clothing welcome</title>
<meta http-equiv="Content-Type" content="text/html; charset=iso-8859-1">
<script language="JavaScript">
<!--
function MM_preloadImages() { //v3.0
 var d=document; if(d.images){ if(!d.MM_p) d.MM_p=new Array();
 var i,j=d.MM_p.length,a=MM_preloadImages.arguments; for(i=0; i<a.length; i++)
 if (a[i].indexOf("#")!=0){ d.MM_p[j]=new Image; d.MM_p[j++].src=a[i];}}
}

function MM_swapImgRestore() { //v3.0
 var i,x,a=document.MM_sr; for(i=0;a&&i<a.length&&(x=a[i])&&x.oSrc;i++) x.src=x.oSrc;
}

function MM_findObj(n, d) { //v3.0
 var p,i,x; if(!d) d=document; if((p=n.indexOf("?"))>0&&parent.frames.length) {
 d=parent.frames[n.substring(p+1)].document; n=n.substring(0,p);}
 if(!(x=d[n])&&d.all) x=d.all[n]; for (i=0;!x&&i<d.forms.length;i++) x=d.forms[i][n];
 for(i=0;!x&&d.layers&&i<d.layers.length;i++) x=MM_findObj(n,d.layers[i].document); return x;
}

function MM_swapImage() { //v3.0
 var i,j=0,x,a=MM_swapImage.arguments; document.MM_sr=new Array; for(i=0;i<(a.length-2);i+=3)
 if ((x=MM_findObj(a[i]))!=null){document.MM_sr[j++]=x; if(!x.oSrc) x.oSrc=x.src; x.src=a[i+2];}
}
//-->
</script>
</head>
<body bgcolor="#FF0099"
onLoad="MM_preloadImages('new_pictures/bottom_button/catalogue_over.jpg','new_pictures/bottom_button/about_over.jpg','new_pictures/bottom_button/get_
...jpg','new_pictures/bottom_button/can_help_over.jpg','new_pictures/bottom_button/news_over.jpg')" text="#000000" link="#000000" alink="#FF3399">
<table width="710" border="0" align="center" cellspacing="0" cellpadding="0" height="446">
<tr>
<td rowspan="3" valign="bottom" width="1"><img src="new_pictures/line/line_v.gif" width="1" height="421"></td>
<td rowspan="3" valign="bottom" width="1"><img src="new_pictures/line_h.gif" width="708" height="1"></td>
<td rowspan="3" valign="bottom" width="1"><div align="right"><img src="new_pictures/line_v.gif" width="1" height="421"></div></td>
</tr>
<tr>
<td height="434" valign="top">
<table width="708" border="0" cellspacing="0" cellpadding="0" height="13">
<tr>
<td><img src="new_pictures/london_paris...gif" width="708" height="13" name="london_Paris"></td>
</tr>
</table>
<table width="708" border="0" cellspacing="0" cellpadding="0">
<tr>
<td><img src="new_pictures/stripe_background_color.gif" width="708" height="10" name="transp_line"></td>
</tr>
<tr>
<td><img src="new_pictures/line_h.gif" width="708" height="1" name="h_lineC"></td>
</tr>
</table>
<table width="708" border="0" cellspacing="0" cellpadding="0" height="65">
<tr>
<td height="65" width="486" bgcolor="#FFFFFF"><img src="new_pictures/anim_welcome.gif" width="486" height="35" name="animation"></td>
<td rowspan="2" width="222" height="65"><div align="center"><img src="new_pictures/logotop222_65.gif" width="222" height="65" name="logo"></div></td>
</tr>
<tr>
<td><table width="486" border="0" cellspacing="0" cellpadding="0" height="30">
<tr>
<td bgcolor="#FFFFFF" width="53">
<div align="center"><font face="Arial, Helvetica, sans-serif" size="2"><a href="trousers.html">trousers</a></font></div>
```

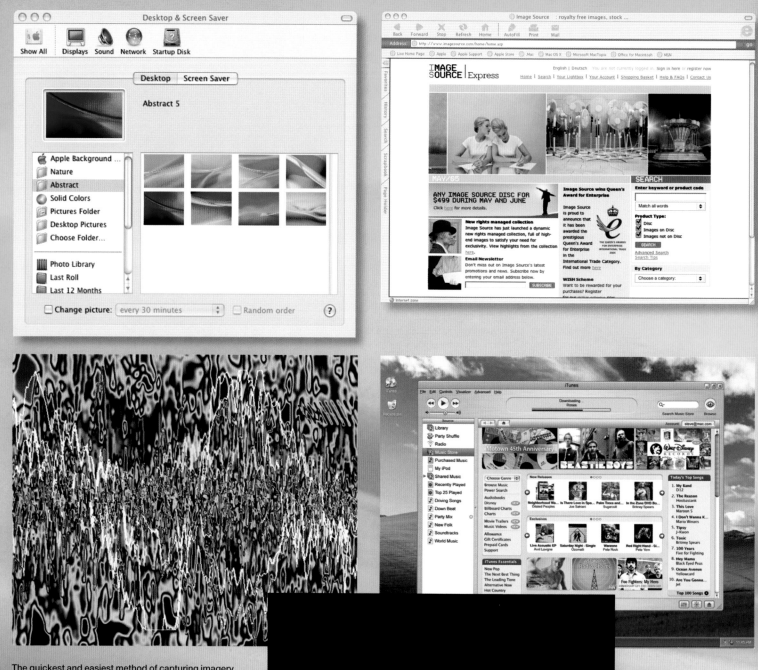

The quickest and easiest method of capturing imagery is to make a screengrab. You can capture the entire screen, a single open panel, or a small section.

Top: The Macintosh system contains background patterns and images for the screen.

Above and right: **Apple iTunes.** Ready-made abstract art. Screengrabs made from the "Visualizer," the seemingly infinite animated pattern maker, make the perfect basis for backgrounds to your own creations. Microsoft's Media Player offers similar effects.

1.3

The interface > Grabbing screens

So the interface images are all there, but if you can't find the originals buried deep in the system, how do you get hold of them? The answer is simple—screengrab them.

Any image that appears on your screen has already been laid out in the computer's memory, so all you need to do is copy that bit of memory and save it as a new file. The size of the image will depend on the resolution setting of your monitor, and the number of colors your screen is capable of displaying.

Both Macs and PCs can perform a basic screen capture with the press of a few keys. Command+Shift+3 will grab the entire screen on a Mac, saving it to your desktop as a PDF file. To take a picture of part of the screen, press Command+Shift+4, then drag the cursor to select the area you want in the picture. To take a picture of a single window, the menu bar, the Dock, or another area, press Command+Shift+4, then press the Space bar. Move the pointer over the area you want so that it's highlighted, then click.

If you want to put the screen shot in the clipboard, rather than create a file, hold down the Control key when you press the other keys. You can then paste the picture into a document. The process is similar on a PC: hit the Print Screen button on the keyboard to copy the entire contents of the screen to the clipboard, where it can then be pasted into a graphics application.

The Mac OS X operating system includes a small screen capture application called "Grab." This allows you to perform the same capture functions, but also gives you the option to save the file in different formats which can then be easily opened in image-manipulation software.

There are a number of screen capture applications on the market, some available as free downloads on the Internet. HyperSnap-DX, ScreenShot Pro, Screen Catcher, and Captivate Select all offer varying degrees of sophistication when selecting the area to capture, or saving the captured file. These utilities also allow you to include the cursor, or arrow, in your grab. When you use the computer's built-in grabbing software, the act of pressing the keys to make the grab may change what is on the screen, including the cursor.

With the help of some simple image-manipulation software you can now start to use any pictures, documents, spreadsheets, or web pages that are displayed on your screen as building blocks for your digital artworks.

Left: By using "copy and paste" commands, pictures can be rapidly created with even the most basic software—in this case, AppleWorks. A triangle was drawn using the triangle shape tool, filled with a color blend, and then duplicated many times. Each time a duplication was made, the size and rotation of the shape was quickly altered by dragging one the corners.

Right: The basic principle behind a digital "brush" is that a small image is repeated along the line you draw. The size, direction, color, and opacity of the image can all be controlled within defined parameters.

1.4

Making marks > Cloning, copying, and pasting

The computer was originally designed to perform multiple numerical operations at great speed. From Charles Babbage's 19th century "calculating engines" to the code-breaking "bombs" of Alan Turing at Bletchley Park during World War II, this had always been the aim.

What the modern computer can do extremely well is carry out tedious, repetitive tasks instantly and efficiently. The ability to copy and duplicate at speed, either by using a keystroke command, or as part of a processing function, is fundamental to the development of digital art.

The basic principle behind a digital "brush" is that a small image is repeated along the line you draw. Characteristics such as the size of that image, its direction, the repeat distance, how much the repeated shapes diverge from the path, variations in color, opacity, and so on can all be controlled within defined parameters. What the machine is doing is performing repeated actions at such high speed that it appears the drawing of the line is a fluid operation.

Individual shapes, lines, images, small sections, or groups can all be copied and repeated, or "pasted," either in the page you are working on or in a new document. It is easy to try out many different versions of an idea until you hit upon a working solution. Using a computer encourages experimentation.

Pressing Command (on a Mac)/Control (on a PC)+C will copy any selection to the computer's memory, known as the clipboard. Command/Control+V will "paste" the selection into the page. Some software also uses Command/Control+D to duplicate a selection, and repeated use of the keystrokes will produce multiple duplications. The "cubist" illustration opposite was created in a very simple software package, AppleWorks. A triangle was drawn using the triangle shape tool, filled with a color blend and then duplicated many times. Each time a duplication was made, the size and rotation of the shape was quickly altered by dragging or twisting one the corners. The animated result took only minutes to complete.

Many of the examples demonstrated in this book were created using copy and paste commands activated via keyboard shortcuts. However, digital art can also be produced by the machine itself; computations resulting from programmed instructions that direct the machine to place or copy a pixel in a given or random position. Complex layers of pixels can be generated at amazing speed.

Once the techniques of copying and pasting have been mastered, they can be used in any software you choose; even for the traditional artist, the advantages of using processing power will quickly become apparent.

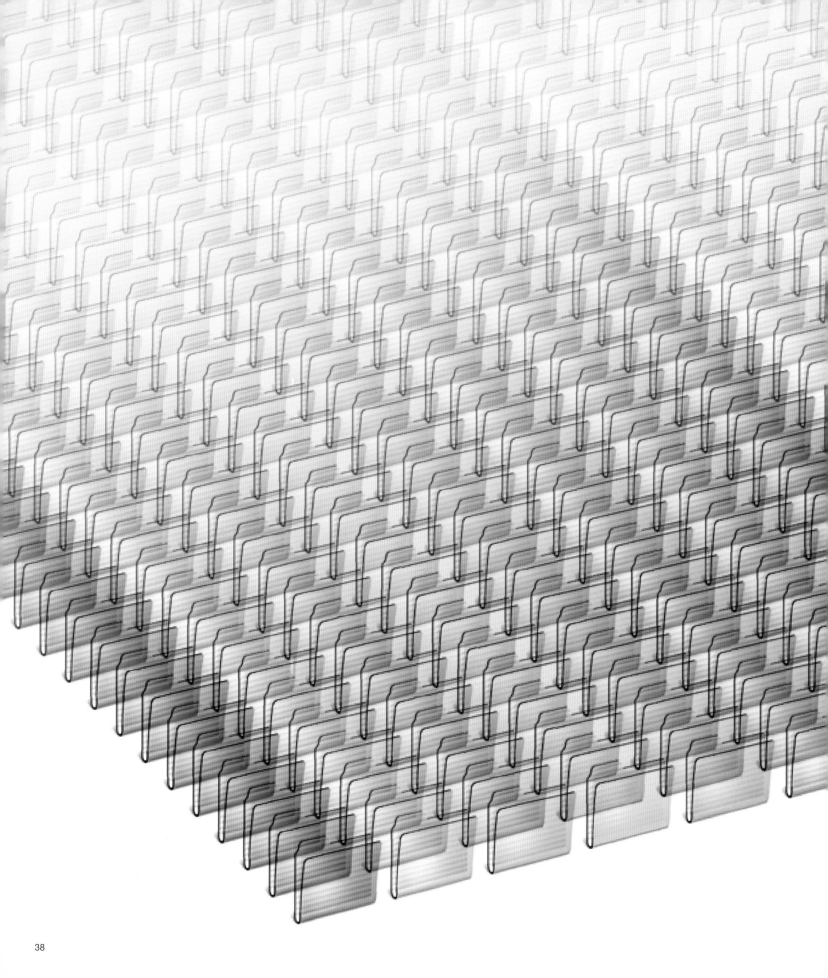

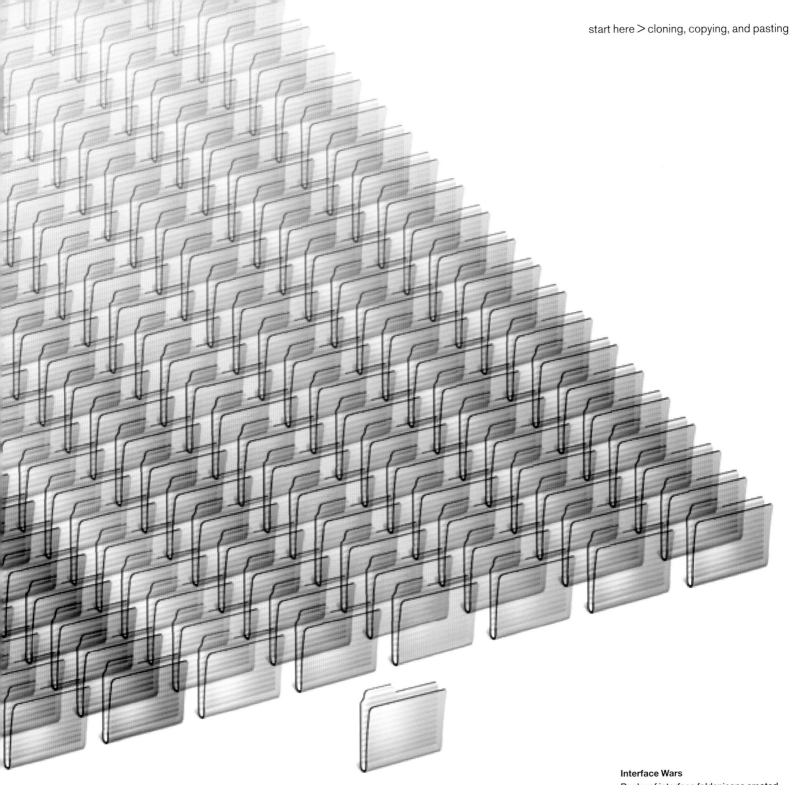

Interface Wars
Ranks of interface folder icons created
from a single screengrab. The color
values of the grab were changed (in
Photoshop Elements), and each resaved
with an appropriate name. The seven
colored folders were aligned, grouped,
copied and pasted and positioned to
form a line. This line of 14 folders was
duplicated (Shift+Option/Alt+Command/
Control+D) to produce ranks of folders.
Each line was reduced in opacity by 5%.

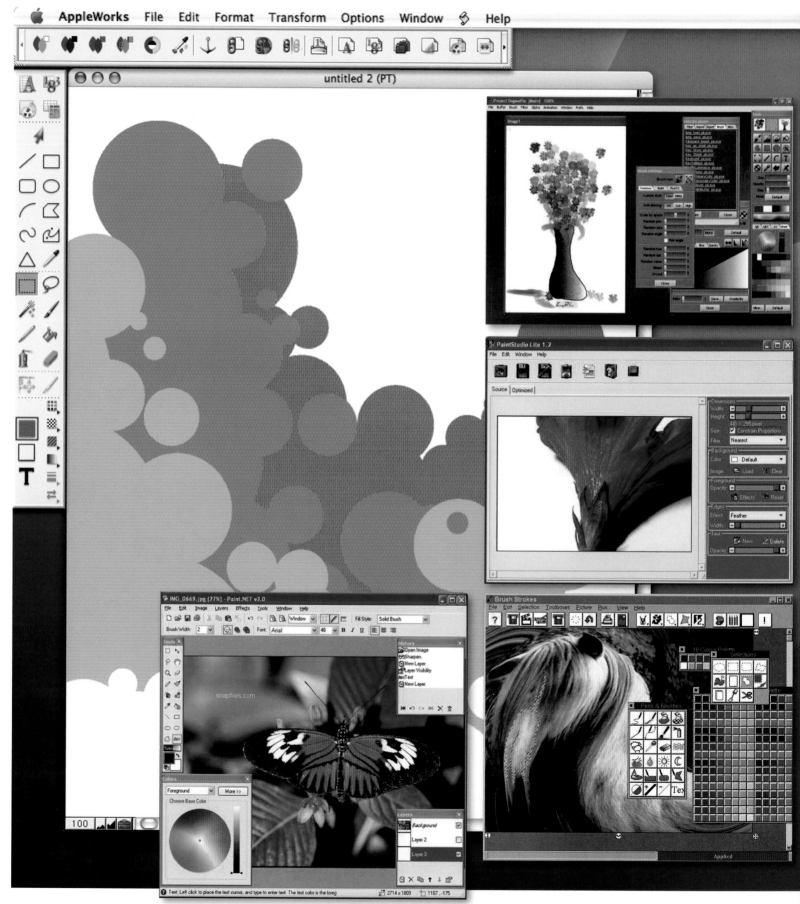

Left: Painting software doesn't have to be expensive. AppleWorks comes free with most Macs; Paint comes pre-installed on all Windows PCs, and there are many other applications available. Shown here are Dogwaffle, Paint Studio Lite, Brush Strokes, and Paint.net. All of these applications offer enough features to get you started in the world of digital art.

1.5

What you can use > **Software**

Almost any application that can display a line or a colored shape can be employed as the starting point for a piece of art–anything from a spreadsheet to a web browser. However, once you have the elements, you need the facility to manipulate and play with them. The more sophisticated the software at your disposal, the easier it will be to make your ideas reality.

Digital art is created in two main ways: bitmap for painting and image manipulation, and vector for drawing. There are other hybrid applications such as 3D modeling programs, in which a 3D vector mesh is created and then covered with a bitmap skin. This generally requires very sophisticated software and lots of computing power, which puts it out of the scope of this book.

When you buy your computer system, it often comes loaded with a basic drawing and painting package, primarily designed for the creation of greetings cards, certificates, and charts for business documents. These relatively simple packages, AppleWorks for Mac and Paint for Windows, offer an assortment of shapes, brushes, and pattern fills. Though restricted in operation compared to the professional applications, there are sufficient tools to get started and give the aspiring computer artist opportunity to play with the concepts of color and shape. The software is supplied with a selection of clip art, but other images can be imported and used as templates to practice drawing skills.

If you want to get serious about your art, then you will need to consider purchasing some software specifically designed for the purpose, and there are a range of moderately priced painting and drawing programs to choose from. The choice of photographic image manipulation software is even greater. Most software developers allow you to try out their wares free of charge for a limited period before you purchase, so it's a good idea to scan the Web to see what is available.

The Windows platform, due to its larger presence in the home market, has the greatest choice. Applications such as Paint Shop Pro, ArtRage, Wizardbrush, BrushStrokes, Paint.net, Paint Studio Lite, Image Broadway, e-paint, and Dogwaffle all offer varying degrees of sophistication and image manipulation, some even providing "natural media" painting tools. The Mac OS is not as popular for the independent software developer, so the choice is more restricted. There are some interesting and useful programs; idraw, Painting for Mac, and Rainbow Painter all come in at under forty dollars. If you don't want to make an investment immediately, some of the more moderate programs are available to download form the Web as "freeware."

In the mid to high price range, the creative opportunities become more interesting. Dabbler, Expression, Studio Artist, ZBrush, Deneba Canvas, and Corel Draw all offer highly advanced tools, with choices of brush, media and surface.

Left: ArtRage painting software for Windows enables you to draw on a virtual canvas using virtual drawing tools, and to produce realistic digital paintings. It offers several drawing tools, as well as a virtual palette knife and different canvas styles. It even comes with a virtual water glass to dip your paint brush into.

Below: Rainbow Painter and idraw, two of the cheaper options for the Mac user who wants to investigate digital art.

Right, top down: Screenshots from Photoshop, Illustrator, and Painter.

Far right: Two of the many "plug-ins" available for Photoshop: Flaming Pear and Eye Candy 4000. Both provide customizable filters allowing you to achieve an almost infinite range of results.

The three programs that set the benchmark and stand head and shoulders above the rest, however, are Adobe Photoshop for image manipulation, Adobe Illustrator for drawing and illustration, and Corel Painter for a more traditional approach to artistic expression with natural media brushes.

Photoshop was primarily designed for retouching and montaging photographic images, but the software can be used to generate art from scratch. The brush tools can be used for accurate line work or freehand sketching, and Photoshop is often used to enhance or finish work begun in a vector drawing application, adding shading, texture, or one of the many filter effects.

Like Photoshop, Corel Painter is fundamentally a bitmap editor, but its tools—including wet and dry brushes, chalks and crayons, inks, and washes—are aimed at the artist rather than the photo retoucher, and have enticed many traditional painters into the digital arena.

The "professional" packages all come at a price, but if you are committed to taking up digital art, they are worth the investment. Thankfully, Adobe, the developers of Photoshop, saw the potential market for the non-professional creative user, and released a more reasonably priced version of their flagship product, called Photoshop Elements.

The main limitation of the high-end imaging software is that it imposes extremely heavy data processing tasks on the computer. This means that speed of operation may slow to a crawl when producing complex artwork, and an artist's expressive flow can be frustratingly interrupted. Fortunately, as computer technology rapidly advances, processing speed is catching up with the demands of the software and its users.

Even though Photoshop and Illustrator include numerous tools and special effects filters, third-party developers offer many additional modules, known as "plug-ins," available to

download from the developers' websites. The effects produced by these add-on filters vary considerably. Some provide controls to create special metal, liquid, smoke, fire, or stone effects. Some disregard the original image altogether, simulating planets, randomly swirling colored backgrounds, or amazing lighting effects. There are even vector plug-ins that can wrap artwork around shapes, creating three-dimensional results.

As computing hardware technology develops, so does the software available to the creative user. One of the few drawbacks to this evolution is that almost as soon as you have acquired the latest version of a particular application, it is superseded by a yet newer version. When you buy software it is worth registering with the manufacturer to receive any free updates, as they are often offered as part of the initial purchase.

Below: An illustration created with vector software. The image is built using multiple Bézier curves to create shapes, and filled with solid color. When enlarged by 750% the image remains sharp.

Below: The same image as a bitmap file. At 300dpi it appears sharp, but when enlarged by 750% the pixels become visible, making the image appear soft and out of focus.

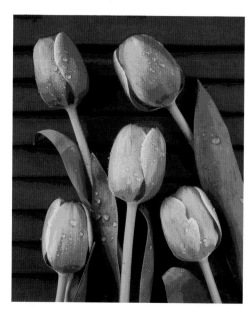

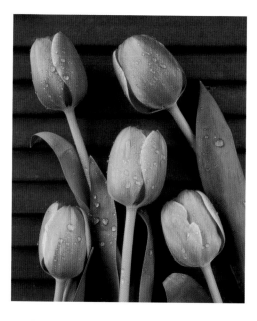

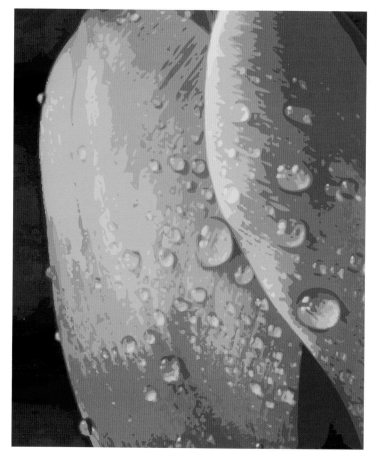

1.6

Dedicated software > **Bitmaps and Vectors**

Bitmap and vector software can be equally useful to the digital artist. Understanding how they operate and then mixing and matching the techniques will allow you to exploit the full potential of your digital creativity.

A bitmap image consists of a regular pattern of tiny squares, known as pixels. These pixels are so small that you do not perceive them as squares, but as a continuous tone of the millions of colors that can be used in their make-up. When using a bitmap application, you create marks on the screen in the same way that you draw on paper, or paint on canvas—with a selection of tools, such as brushes and pencils. Professional software includes vast numbers of additional controls, enabling you to manipulate any aspect of the picture, including color, texture, and numerous "filter" effects. You can copy single pixels or whole sections, or remove areas with an eraser.

Bitmap applications have two fundamental elements— masks and layers. Masks allow you to make changes to selected areas of your artwork, while leaving others unaffected. Layers enable you to manipulate elements independently. Layers can be stacked in any order, and can have different transparency or blending modes applied. A layer can be duplicated, the copy worked on and later discarded if the result is not satisfactory.

The important issue with a bitmap image is its resolution, or the number of pixels that make up the image. The computer screen has the effect of blurring pixels together, so a low resolution of 72 pixels (or "dots") per inch (a grid of 72 x 72 pixels per square inch of the image) is sufficient if the image is only going to be viewed on screen.

However, if the image is going to be printed, then it needs to be a bit more refined. When a 72ppi image is printed, the pixels become apparent and the result is "blocky" and indistinct. The typical resolution required for printing is 300dpi. When you start a piece of artwork in a bitmap application you must set the resolution for the final printed size. If you set it at 300dpi for an image size of 2 x 2 inches, and then print the image at full page size, the effective printed result will only be 60dpi and look very coarse and "pixelated." It is possible to "resample" a small image to a larger physical size at a higher resolution, but though the blocky pixel effect may be lost, the image will always appear to be blurred.

A vector image is created by lines and objects that will look sharp whatever the output size. The objects and lines can easily be reshaped, recolored, and resized with no loss of quality. Each element faithfully retains its designated shape and characteristics when reduced or enlarged to any degree.

Basic circular or rectangular shapes are usually "drawn" with a shape tool, and complex shapes drawn with a pen tool using what are known as Bézier curves. Each curve is defined

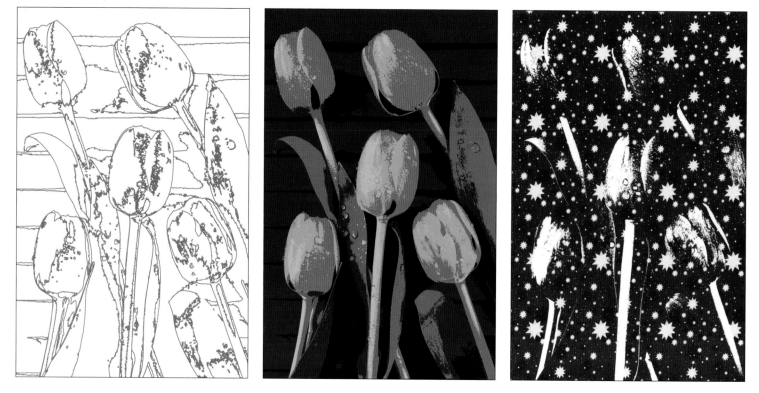

by a start and end point, and two "control" points that govern its shape and direction.

Each object in a vector application is given form by a stroke and a fill. The stroke is the outline of the "path" and can be set to any thickness, color, or customized characteristic the software allows. Adobe Illustrator, for example, has multiple libraries of strokes and brushes. The stroke can also be set to "none" if no outline is required.

The fill does exactly that: it fills the shape with either a simple flat color, or more complex gradients or patterns. Blends of color can be created by drawing a path in a dark color and another inside the original in a lighter color. A smooth blend of color between the two is mathematically generated by creating multiple steps between the objects. The more steps the software can produce, the smoother the blend will appear.

By its very nature, a vector application uses a layer system. Each new object created appears in front of the previous object. The stacking order of the objects can be rearranged by using keystroke commands. Several objects can be grouped, allowing them to be moved or scaled as one, and this group will occupy a single place in the stacking order. Often the number of objects can be so large that it makes a document very difficult to manage. To overcome this problem, vector applications, like bitmap, also provide the option to use a system of "layers," making it easier to locate, select, or hide individual elements.

Bitmap images can be imported or pasted into vector artwork, though the options to edit them are limited. Vector artwork can also be imported into a bitmap document. However, be aware that this may result in "rasterization" of the vector image—in other words, converting it to pixels and so losing the vector path.

Like the vector "fill" and "stroke" swatch libraries, bitmap applications include collections of "styles." The styles range from background fills, composed of step-and-repeat "tile" patterns, to virtual three-dimensional lighting effects. They give you a simple way of adding drop shadows, applying strokes,

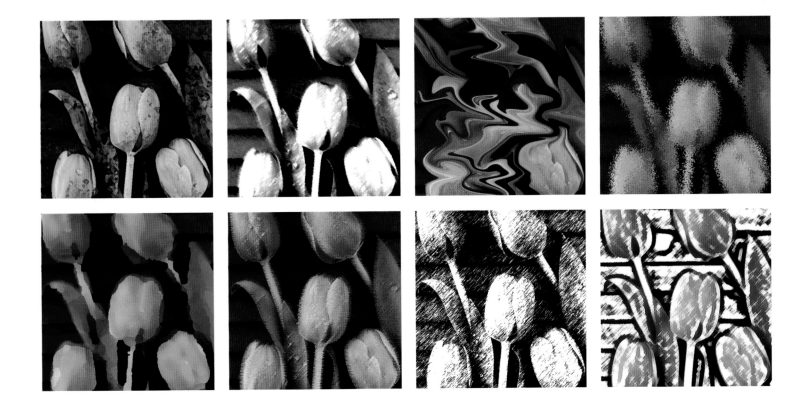

Opposite: Vector graphics are given their form by a stroke and a fill. The stroke can be a simple outline in the color and thickness of your choice. The Fill for each path may be a solid color, or (right) a pattern applied from the libraries supplied with the software, or even a "custom fill" created by the artist.

Above: Sophisticated bitmap applications can turn you into an artist at the touch of a button. This bitmap image has been transformed by the following Photoshop Filter Effects:

Top row, left to right: Fresco, Chalk and Charcoal, Liquify, Spatter.

Bottom row, left to right: Palette Knife, Rough Pastels, Graphic Pen, and Colored Pencil.

or simulating surface textures like metal or wood. Unlike their vector counterparts, the bitmap styles are infinitely editable–a fill pattern can be scaled or rotated to suit the subject, or the transparency modified. Once the technique has been mastered, custom styles can be saved to the palettes for future use.

Both bitmap and vector software offer tools that provide distortion effects, making it possible to change perspective, stretch, twist, "pinch", or "wave" objects. Again, the bitmap approach is usually far more sophisticated and the tools more controllable.

One of the most powerful features of Photoshop, the most widely used "professional" bitmap application, is its array of filter effects. Like a photographic filter, you attach to the lens of your camera to physically alter a photograph, the filter effects digitally modify the image. The effects produced can be a real asset to the digital artist, ranging from the artistic to the extreme. The filters can transform an image to a pencil sketch, a watercolor painting, brush stokes applied to canvas, or even make it look like a photocopy. You can solarize, blur, sharpen, create "tile" or liquid effects–the options offer huge scope for creativity.

1.7

Saving your work > **File formats**

As the size of graphic- or art-based files is often quite large, it is good practice to save your work at regular intervals during the creative process. The image file types that can be used depend on how you want to view or present the finished art, or on the software used to create it. The most common formats used to save digital image files are as follows:

JPEG The JPEG format uses a compression method known as "lossy." Devised by the Joint Photographic Experts Group, this cleverly removes the least noticeable color information to keep the size of the file as small as possible. The more compression you apply, the smaller the file becomes—and the more visible the degradation. This format is good for web graphics, and useful for sending full-page, full-color images to print without uploading massive files; but it should never be used to save images you want to manipulate further, as "compression artifacts," such as blocks and streaks, will become more and more obvious.

EPS PostScript is the universal language used for commercial print output. An Encapsulated PostScript file supports clipping paths for image cut-outs, and generally can't be altered in page layout or prepress software, unless you are using the latest Adobe Creative Suite package. The file format is not very compact, meaning the size of the file will be relatively large.

TIFF Tagged Image File Format is often used by graphics professionals. TIFFs work with all serious graphics programs on all operating systems. It is also possible to store layer and channel information in TIFFs. Not all programs can read this information, but those that don't will open the TIFFs as flattened files. Storing this extra information will result in larger file sizes, so it's best to save flattened TIFFs if the extra layer information isn't going to be required.

GIF Used for the Web, the Graphics Interchange Format was popularized by the online service CompuServe, and is widely used for icons, graphics, and blocks of preset text. It devotes only one byte (8 bits) of data to each pixel, giving 256 colors rather than millions. Certain pixels can be transparent, so a web page's background will show up behind an irregularly shaped picture. Using suitable software, you can also store several images within a file, and a web browser can display each in turn, creating a simple animation.

If the colors in your artwork are important (as they should be!), it is important when saving a file to pay special attention to the color mode you have selected. The colors you see on screen will not necessarily be the colors you see on paper, if that is your preferred output method.

File saving options provided by
Photoshop. Saving for a high resolution
print and saving for solely web viewing
require different compression modes to
determine the arrangement of the pixels
and the final size of the image.

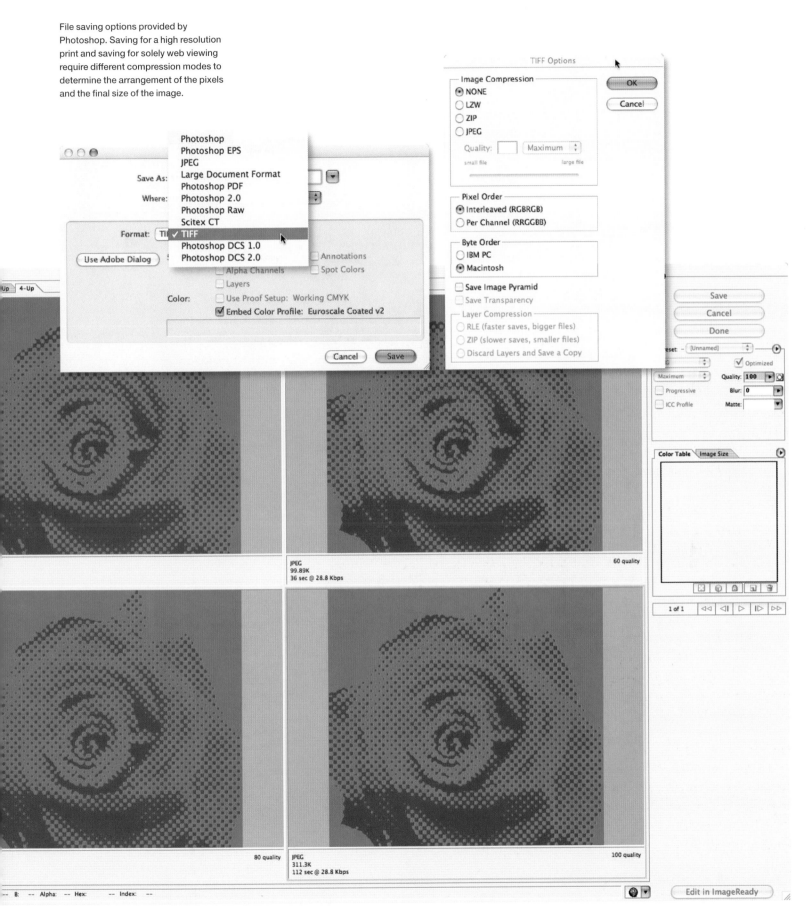

screen

RGB

print

CMY

K?

The "additive" colors used on screen are red, green, and blue. The "subtractive" primary colors are cyan, magenta, and yellow—so why do we need black ink too? The fact is, printing inks and the material they're printed on aren't perfect. Mixing solid cyan, magenta, and yellow doesn't give a solid black, but a muddy brown color, so we need to add a proper black ink. The black is known as K for "key". It's also simpler to print black-only items such as text, rules, and line-work using one ink. Otherwise the register (the alignment) of the overprinting inks becomes an issue. Black ink is cheaper, too, and a single ink will dry faster than three. The way that the black plate is generated in a CMYK file is critical to its printability and quality. When printing a CMYK file you are often given the option to "overprint" black, or print black as a solid color.

1.8

Saving your work > **Color modes**

Entire books have been written on the subject of digital color—it is a science in its own right. However, the digital artist should understand the basic concepts of how color works.

When light from all the different wavelengths, or colors, is mixed together, white light is produced. Mixing combinations of the primary colors red, green, and blue creates all the other colors. This is known as additive color mixing, and the way to remember this is that adding all the colors together makes white. Computer monitors and TV screens use additive color mixing to create color images. This color mode is abbreviated and commonly known as RGB.

When we want to output color to paper or other surfaces, we have to change to what's called subtractive color mixing. When we look at the ink on our paper using white light, which contains all colors, some of the colors are reflected and some absorbed, or subtracted, from the light. Cyan ink absorbs red but reflects green and blue light; yellow absorbs blue but reflects red and green; magenta absorbs green but reflects red and blue. Mixing these primary colors results in more color being subtracted from the reflected light: cyan and yellow together subtract blue and red, leaving just green; magenta and yellow together subtract green and blue, leaving just red; and so on. Adding all three primaries subtracts all the reflected colors and gives us black.

When you output your work to a particular device, to get an accurate representation of the color on your screen, the printer needs to understand the color "space" you are working in. Accurately passing the color information from one device to another is done by a color management system (CMS). For the CMS to function, the digital file is assigned a color profile. This means color data can be translated between any two color spaces as long as a profile has been installed for each of them. The monitor you are using will have its own color profile, which should be installed in the computer's system software. If not, it is easy to calibrate by eye, following a calibration "wizard."

Saving a digital file using graphic software, you may be asked to embed a color profile. This will be determined by the output method you require. If you are using a low-cost inkjet printer, and the printing software supplied with the machine included no specific color profile, then a general CMYK profile should be selected. Saving a file for commercial reproduction will require one of the industry-standard profiles, such as Euroscale Coated, to be embedded for the press to accurately output the desired color. Adobe uses a standard RGB profile, included in all its products, which provides a comprehensive color spectrum and can be shared with many applications and hardware devices, including scanners and printers.

Masters of the art > Charles Csuri

Charles Csuri may be the closest thing, in the world of digital art, to an Old Master. Initially a traditional artist, Csuri pioneered the creative use of computers to produce images and even animation as early as 1965. Today Csuri utilizes sophisticated computing power to let him sculpt images in three dimensions, view them from any angle, set them in motion, and alter them in ways that often blur the distinctions between special effects and art. Although some of his work is done with a mouse, moving a cursor around the screen, much of it still requires knowledge of

programming. Csuri, however, insists that he is not interested in technology for its own sake.

"Just because the computer can do perspective and beautiful shadows and shininess, or make things look like glass, you still need to have an aesthetic sensibility; you need a sense of culture and history. That has not changed. Even though we have all this marvelous technology, the problems for the artist are still the same. You can very easily be seduced by some special effect, but that in and of itself doesn't do it. You have to have some way of communicating what you feel as a human being."

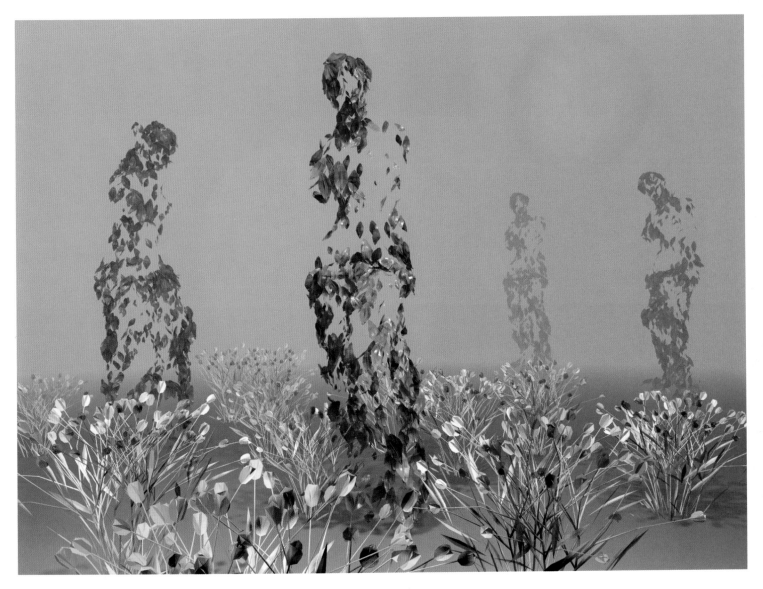

The Scribbles Series

"This group of images emphasizes graphical and linear qualities. I am intrigued by the qualities of sketches in a three-dimensional world space. This goes back to my love of sketches and drawings by the old masters. I also love the prints of the Japanese master Utamaro. However, unlike a two-dimensional drawing, my ribbon-like structures reflect light based upon their angular relationship to the light sources. There is also a greater emphasis upon the three-dimensional space. I enjoy images that appear as a form of graffiti—meaningless marks or some private code. They were really inspired by the drawings of my granddaughter at her pre-schematic phase when there was no clear subject matter.

I wrote computer programs in AL (a language for animating in 3D) to generate the images. I used a mathematical function called the b-spline to generate the shapes. The b-spline was also selected because of its curvilinear quality, which offers elegance and beauty. The basic geometry of the objects is comprised of patches (3D surfaces) to work with Renderman and Blue Moon Rendering Tools (BMRT). This special function was written for me by Dr. Steve May of Pixar Inc. While the software does many things automatically, I found that it takes a great deal of trial and error adjusting parameters before I am satisfied with the ribbon-like representation."

Charles A. Csuri
www.csurivision.com

Part 2

pictures
with pixels >

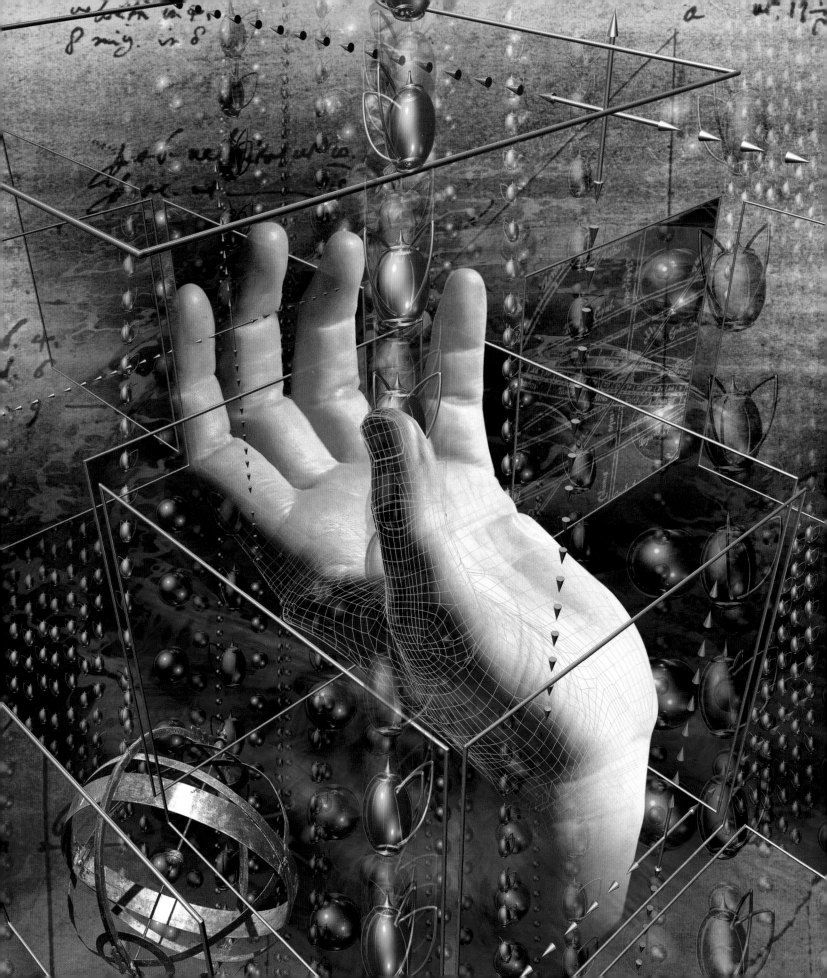

Left: Multilayered illustration
by Canadian artist Derek Lea.

2.1

Pictures with pixels > Using layers

Working with layers is one of the real creative advantages when using a bitmap application. Elements of the artwork can be maintained as separate entities and the way each layer is combined to create the final image can be finely controlled.

When you open a new document in a pixel-based application, such as Photoshop, there is automatically one layer present, normally called the "background," that is filled with white. Adding a new layer will produce a transparent layer, so the background will show through. Any new layer added subsequently will appear on top of the previous one, and will be added to the Layers "palette." Layers can be switched off, meaning they become invisible, or can be individually selected. This means you can work on any selected or "active" layer at any time and none of the other layers will be affected. Pasting a new selection into the document will create a new layer, and its position in the "stacking order" can be moved as desired.

Layers can be grouped into sets allowing collections of layers to be shown or hidden, or moved to the front or back of the layer stack. When the document is saved you are given the option to "merge" the layers, meaning they are compressed or flattened into a single composite image.

Opacity and blending modes control exactly how the pixels of one layer interact with the layer below, and these can be finely tuned. If no blending mode is set, then the pixels from a higher layer will simply overwrite the layer below. When a blending mode is selected, a predetermined formula will instruct the software to change the color values of the two juxtaposed layers. For example, Multiply will multiply together the pixel color values of the two layers, resulting in a darker image. Screen will do the reverse, multiplying the inverse color values to create a lighter result. Photoshop provides a choice of twenty-three different blending modes.

Another advantage of the layer system is the "adjustment layer." This is a layer that contains no pixel information, but only information about the adjustment, which affects the pixels in the layer immediately below it. Any adjustments that can be applied to the image, such as brightness, contrast, or color saturation, can be applied to an adjustment layer. The advantage to this is that the image layer itself is not altered, and the adjustment layer can easily be modified or deleted, giving absolute creative flexibility.

The use of layers has led to the creation of highly complex works of art. Having the ability to add multiple new layer elements, keeping them separate, and having the freedom to move or blend them with others has led to the development of images with extraordinary depth and movement.

Of course, not all multilayered images are visually successful. When setting out to create this type of illustration, a good eye and sense of conceptual direction are perhaps of

Photoshop provides a variety of effects, such as shadows, glows, bevels, overlays, and strokes that let you quickly change the appearance of a layer's contents. Any applied layer effect is linked to the contents of the layer. When you move or edit the layer, the effects are modified accordingly.

For example, if you apply a drop shadow effect to a text layer, the shadow changes automatically as you edit the text.

The effects that you apply to a layer become part of the layer's "custom" style. You can open the style in the Layers palette to view or edit any of the individual effects that compose it.

even greater importance than with conventional artwork, it is far too easy to end up with a meaningless jumble. Usually, one dominant image forms the basis on which the montage is built. The raw material might be grabbed from the Web, or scanned from artwork. Geometrical or organic forms, explosive patterns of light, and striking colors can all be added to the image to grab attention. An illusion of three-dimensional depth can be created by dimming, lightening, de-saturating, or blurring elements, and the impression of movement can be achieved by repeating objects at different scales, colors, and opacities.

To undertake this type of art, a thorough understanding of the various layer types and modes is essential, and this can only be gained by experience. Blending modes such as Color Burn, Lighten, and Overlay are particularly useful for building up dense images, as they preserve the imagery of the underlying layers. Foreground elements can be cut out using transparency or layer masks, and adjustment layers can be used to change the color or brightness of certain elements.

The disadvantage of using layers comes with the file size. File sizes of single images are determined by their resolution, but the amount of data in a layered document is unlimited: the more layers you use, the larger the file, and the harder your processor has to work. Once you are satisfied with your creation, a copy should be saved as a single image with the layers "merged" or "flattened" to make a more manageable file size.

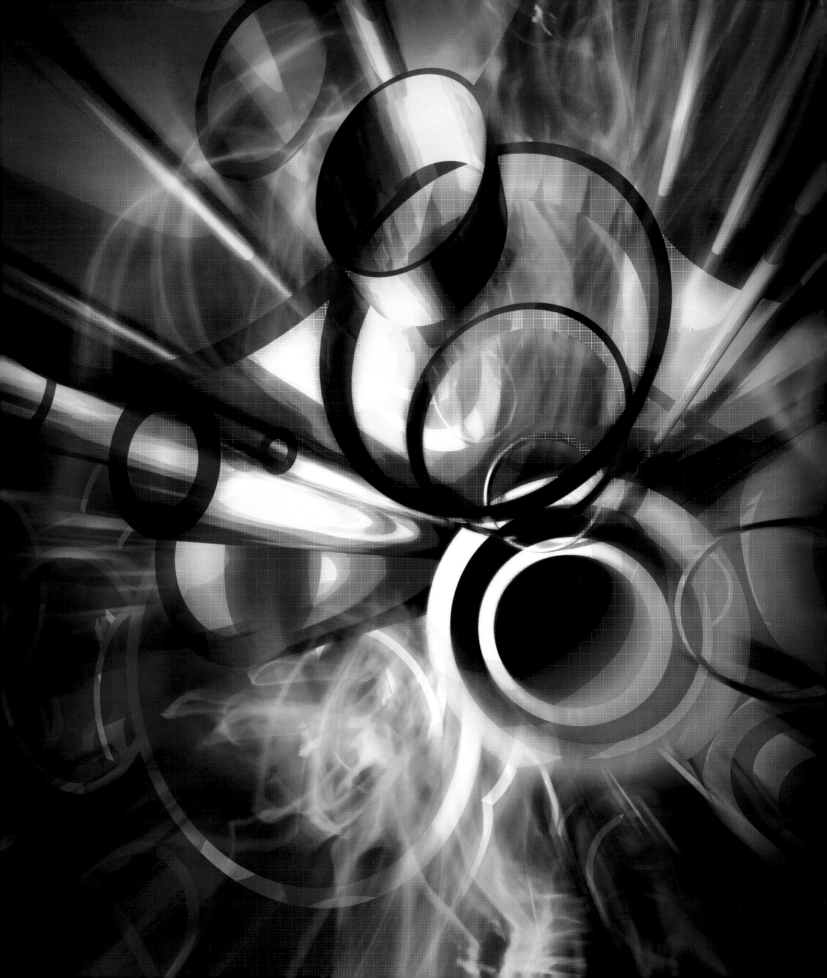

Images created from simple shapes drawn using bitmap software. A solid color fill was applied to each element with a Paint Bucket tool, and the colors chosen using the color picker. Each shape was created in a separate layer, the layer was duplicated, and a degree of blur applied. The blending mode of each layer was subsequently changed in a process of trial and error.

Top layer

Darken

Multiply

Color Burn

Linear Burn

Background layer

Lighten

Screen

Color Dodge

Linear Dodge

Overlay

Soft Light

Hard Light

Vivid Light

Linear Light

Pin Light

Hard Mix

Difference

The results of applying some of the different blending modes to the upper layer of a two layer Photoshop image. All the examples show the blend applied at 100%. Infinite variations can be achieved by changing the opacity or by fading the blend.

Hue

Saturation

Color

Luminosity

Top far left: **PANTONE** is the best known color specification system in the U.K., Europe, and the U.S.A. Each color is defined by a formula that tells the printer how to mix primary colors to create the exact shade.

Left: **PANTONE to CMYK**, or process conversion values are available in most graphic programs, but only about half will give a perfect match to the spot color.

Below far left: The Trumatch system is based on standard CMYK printing, and organizes 50 hue families into 40 perfectly proportioned tints of each.

Below left: Focoltone (from "four color tone") is also CMYK-based. 763 colors can either be process printed or pre-mixed by the printer as solid spot colors.

Right: The most commonly recognized on-screen color picker is the color wheel, offering a spectrum of RGB hues.

Below right: Rather than the traditional wheel, the Adobe Color Picker uses a rectangular chart to depict light to dark and gray to saturation. The starting point is selected from a vertically arranged spectrum. You also have the choice of viewing the colors from a number of standard systems as a scrollable list.

2.2

Using pixels > Picking color

The use of color is one of the most important aspects of the visual arts. The subtlety of variation, light, and shade, or the juxtaposition of contrasting hues all play a key role in the creative process. Fortunately, choosing, changing, and experimenting with color is one of the computer's great assets.

Most computer operating systems and graphics programs manage the choice of color through a "color picker," usually taking the form of an RGB color wheel. Applications from Adobe, including Photoshop and Illustrator, are an exception. Hues in these programs are displayed in a vertical line presenting saturation, and lightness variations are displayed in a chart progressing from dark to light on the vertical axis and from 0 to 100% saturated on the horizontal.

Color can be "picked" at the click of the mouse, simply by placing the cursor in the desired area of the wheel or chart. The chosen color is generally automatically added to the current color palette, or the working "toolbox" for future use.

In vector drawing packages, the Swatches palette provides access to industry standard color systems such as Focoltone, PANTONE, Toyo, and Trumatch. These systems can usually be viewed either as a list or as a chart. The chart view displays swatches arranged in an arbitrarily proportioned window; as you resize it, different patterns emerge.

The color system panels installed in applications such as Illustrator can be useful as artistic elements in their own right. Screengrabs of the panels can easily be opened and manipulated in your painting application.

Above left: A screen grab of the Focoltone swatch chart has been blurred using Photoshop's Motion Blur filter on a horizontal axis. The result is duplicated and each copy shifted to the left or right. The resulting dynamic effect resembles the stroke of a large brush.

Far left: Applying filter effects to a screengrab of the PANTONE Process system color chart. The Accented Edges filter removes the black lines and creates a softer, almost painterly effect.

Left: The ZigZag filter, applied at high strength, creates a colorful abstract.

Above: This Focoltone chart has been duplicated five times. A Warp distortion was then applied to each layer by hand to construct this three-dimensional shape.

Right: The Ripple filter followed by a Warp distortion makes a ribbed "shell" effect.

Above: **The Photoshop Brushes palette offers a huge selection of brush types, including airbrushes and textures. Filters can also be applied to each tip style. The Color Dynamics option automatically applies a pre-selected level of random color to the stroke.**

Right: **Bitmap brushes can be customized in several ways. In addition to the brush type and size, the opacity and flow can also be adjusted, which is particularly useful if you are using a pressure-sensitive graphics tablet.**

Right: Painter's brushes are a far closer simulation of natural media than the Photoshop equivalent. They provide accurate representations of everything from smearing thick impasto with a palette knife to sprinkling salt on wet watercolor paint.

2.3

Using pixels > Brushes

Bitmap-based software uses painting "tools" to change the color of the pixels in an image. Brush and Pencil tools work like their traditional counterparts by applying color with strokes. The Gradient and Paint Bucket tools apply color to large areas, and other tools, like Eraser, Blur, and Smudge, modify the existing colors in the image.

Applications such as Photoshop provide a multitude of options that allow you to specify how a tool applies or modifies color. For instance, you can apply color gradually, with soft edges, using large or small brush strokes, various brush dynamics, different blending properties, and with brushes of different shapes. You can even simulate spraying paint with an airbrush.

A "Brushes palette," containing numerous options for setting brush painting characteristics, is available with a number of preset brush options including brush tips, size, and hardness of stroke. It is possible to alter the preset options that vary the size, color, and opacity of brush marks even over the course of a single stroke. When you change a characteristic–for example, the size, shape, or hardness–of a preset brush, the change is only temporary. The next time you choose that preset brush, it reverts to its original settings. To make permanent changes, you need to create and save a new preset. Any selected brush, along with the attributes you specify, such as opacity, blending mode, or paint color, can be saved as a "custom brush" for future use.

Other brush options are available. A "dual" brush uses two different tips to create brush marks. Options for the primary tip can be set in the "Brush Tip Shape" section of the Brushes palette, then a second brush tip can be selected from the "Dual Brush" section.

Corel Painter is a specialized painting application, and has been the leader in creating natural media for more than a decade. Painter can make use of Photoshop plug-ins, but the majority of its features are dedicated to wet and dry brushes, pens, pencils, chalks, crayons, and other tools of the traditional artist. Particularly significant is the provision of wet watercolor layers on which successive strokes can be allowed to run and bleed together as you paint. It is possible to create highly realistic effects, but the added advantage of painting with a digital brush is that you can also carry out operations that would be impossible with real media, such as erasing watercolor.

Painter is such a sophisticated and complex program that to take full advantage of the features, it's almost essential to invest in a graphics tablet. Drawing with the mouse feels clumsy and uncontrolled, but with a tablet, stylus functions such as pressure and tilt can be linked to parameters such as the width and texture of brushstrokes, making the painting experience far more natural.

2.4

Using pixels > **Layer styles**

Styles are an invaluable asset when working with bitmap software. Like brushes, preset styles can be viewed and selected from a "Styles" palette. When using Photoshop, styles can be applied to individual layers with a "Layer Styles" dialog box. These were originally developed to speed the creation of website elements, such as banners and buttons, but can now be applied to any layer for great painting effects.

The range of style possibilities is enormous. Drop Shadow and Inner Shadow add definable degrees of shadow effects; Outer and Inner Glow add light that emanates from the outside or inside edges of the layer's content; and with Bevel and Emboss, numerous combinations of depth and thickness of bevel can be applied either outside or inside a given area. The styles themselves are also hugely customizable, so, staying with Bevel, the mode can be changed from smooth to chiseled to give a hard-edged appearance, or a gloss contour can give the bevel an intricately carved effect. Using a layer style, the layer's content can also be filled with a Color, Gradient, or Pattern overlay, or a stroke can be used to outline the object on the layer, again using a choice of color, gradient, or pattern. This is particularly useful on hard-edged shapes such as type.

Preset styles that simulate realistic surfaces are included in most software packages. Metal, wood, and stone are common choices, though the supplied options invariably require adjustment to provide truly realistic effects. The real advantage in using layer styles is that they don't change the pixels of the artwork on the layer in any way, the effect is added on top of the layer without editing the layer itself. If the artwork is subsequently changed, then the style is automatically applied to the new shape.

Nothing you do to alter a layer style is irrevocable, any of the parameters can be removed or edited at any time. In Photoshop, the individual elements that make up a style are listed in the Layers palette, allowing each to be turned on or off at will. Styles can be dragged from one layer to another to duplicate the effect on another layer, and any preset style can be adapted, manipulated, and resaved as a custom style of your choice.

Above: A selection of Photoshop's layer
styles, each applied to a separate layer
in a document made up of 50 layers.
Photoshop includes a range of presets,
but new styles can be created using the
layer style adjustment options. When
a new style is saved, it is automatically
included in the styles palette.

Left: This artwork could be created using either bitmap or vector software. With a paint application, a vector shape, in this case a long thin rectangle, is drawn and saved as a vector path. In a new layer, the outline of the path is "stroked" with a thin line of black pixels and the path then filled with a solid color. This operation is repeated, each time onto a new layer and with a new fill color. When a few shapes have been created, the layers can be nudged so that the shapes just touch each other. The layers are then "flattened" to create a single multicolored image. This new layer can be duplicated and the colors changed using Hue and Saturation. A Wave filter is then applied to each layer, and the intensity of the filter is slightly altered each time. Finally, each layer is individually rotated using the Free Transform function, and moved to place the shapes in a pleasing dynamic arrangement.

2.5

Pictures with pixels > Lines and shapes

Most painting applications provide the option to draw lines and shapes using both bitmap and vector tools, though the vector operations are generally more limited than those of their dedicated counterparts. Vector lines are known as paths, and strokes and fills of pixels can be applied to individual paths on selected layers that can subsequently be edited or modified.

Vector paths are actually mathematical descriptions of lines that the computer interprets and renders on screen for you. For example, a simple vector instruction might be "draw a line from point A to point B and color it black." The beauty of this is that it is very easy to change any of the properties of the line–its color, style, thickness, or position. Unlike a vector path, when you draw a line using a bitmap tool, the computer simply alters the color of the pixels that form the line. It is fixed on screen, and cannot be easily edited. However, there are creative advantages to bitmaps, as many distortion effects, blending tools, and filters can be brought into play.

When you work with the vector tools in Photoshop, you can draw in three different modes by selecting an appropriate icon in the Options bar when you have a vector tool selected.

The Pen tool can be used to independently draw single or multiple vector paths that can be filled or stroked with color to create bitmap graphics. The vector shape tools create a new shape layer consisting of a vector "mask" that defines the shape outline, linked to a fill that defines the shape color. The outline of the shape is an editable vector path. Shape layers can be created using either the shape or Pen tools, and are easily moved, resized, aligned, and distributed.

Pixel based or "raster" shapes are created by making a selection in the desired shape, and then filling the area with color. Again, when you work in this mode, you are not creating easily editable vector graphics, you are just changing the color of the pixels that make up the shape. Raster shapes can be manipulated using the Transform commands (rotate, scale, skew, distort, and perspective) in one continuous operation. In Photoshop, you can also apply a Warp transformation, allowing you to bend and twist a selected area.

Linear art can be constructed from all sorts of source material grabbed directly from the screen. Try copying a thin vertical slice of any image and then distorting it by stretching horizontally. As the image is stretched, pixels of similar colors are created, making dynamic linear effects. Grabs can even be made of unlikely material. For example, financial graphs can be blurred, distorted with filters, or the colors altered and intensified using Hue and Saturation controls.

Once again the beauty of using layers comes into its own. Shapes and lines can easily be copied, rotated, overlaid, and blended together to create original artwork.

These images were made by duplicating a simple line pattern layer created in Photoshop. With the blending mode of the duplicated layer set to Multiply, the layer can variously be nudged up or down to increase frequency, rotated very slightly to produce a moiré effect, or rotated to 90° to generate a checked pattern—with any degree of variation in between. Of course, the key to the overall effect depends on the aesthetic quality of line in the original pattern, and the only route to a satisfactory result is via experimentation.

In these examples, the original line pattern was created with Photoshop's Halftone Pattern filter. Color was added with the Brush tool and, to increase interest, various Distort filters were applied before being smoothed with the Motion Blur filter. Further interesting results can be achieved by experimenting with layer blending modes.

Opposite: **Four examples of "linear" art created with a freehand paintbrush tool and making use of the Layer Styles functions.**
a) Gradient overlays applied to both the background layer and the stroke.
b) Motion Blur applied to a vertical stroke.
c) An abstract "fire" style on the stroke.
d) Bevel and Emboss filters with an added drop shadow give the impression of paint squeezed from a tube.

Below: **Using Photoshop, a series of vertical paths of different length were drawn equally spaced along a horizontal axis to create a simulated "audio" wave. Various strokes and filters were applied, including Gaussian Blur and Neon Glow. Finally, to give the work a sense of movement, a warp distortion was added.**

Above-left, and Above-center:
Elements grabbed from graphical financial statements can be selected and copied into new layered artwork. There are a plethora of websites devoted to just such visual information. Experiment with your application's filters, blends, and blurs, and add backgrounds filled with gradient effects.

Above: The vector path for this starburst, or flower, shape was imported from a vector file. The new shape was colored and duplicated to make several layers. The position of each layer was arranged manually, the color hue changed, and the blending modes adjusted. The layers were then flattened. The resulting layer was again duplicated, the opacity adjusted, and then manually nudged to create the "out of register" effect.

Left and opposite: Dynamic use of simple circular shapes: created by duplicating, blurring, blending, and adding filter effects to the separate layers.

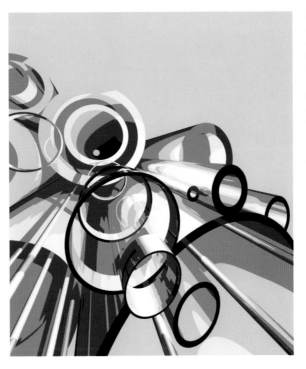

A rasterized shape is made from pixels, so it cannot be edited like a vector object. Once the shape is drawn, it can only be edited using the standard transform, distort, and warp functions. In Photoshop, you can use vector tools to create raster shapes. Choose one of the shape tools from the tool bar, then check the "Fill Pixels" button in the Options bar before you draw your shape. The raster shape is created using the current foreground color, so select your color before drawing the shape.

Various "Mode" controls can also be preselected, which affect how the new shape reacts with other pixels in the image. The opacity determines to what degree the shape will obscure or reveal the pixels beneath it. A shape with 1% opacity appears nearly transparent, while one with 100% opacity appears completely opaque. If the "Anti-alias" box is checked, it has the effect of softening the edge pixels of the shape, and so reduces jagged edges.

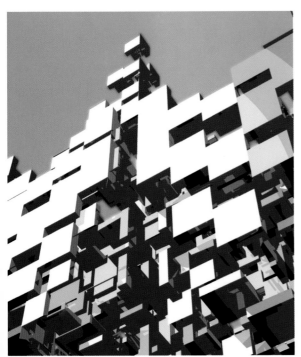

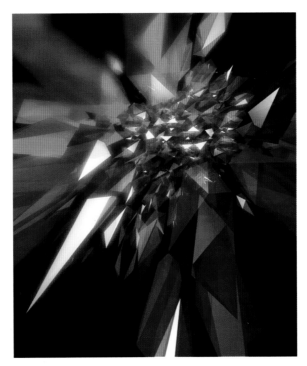

3D effects can be produced using shapes in 2D software. As in traditional art, the skill in three-dimensional representation is based on the artist's knowledge of light and shade and the perspective origination point. Perspective transformation of layered objects is laborious, but can be effective. Bitmap software makes the task slightly easier using the Free Transform controls, which allow unlimited experimentation. The only way to achieve true 3D is by using dedicated software. Both the perspective coordinates and the light source and intensity can be preset, leaving the processor to perform the complex calculations to produce a realistic 3D result.

Right: *Smoke.* An illustration by artist Reinhard Claus, who specializes in digital 3D. This picture was created using Softimage XSI, and rendered with Mental Ray. It is an experiment in rendering with what are known in 3D software as "volumetric shaders" without use of surface shaders or lights. Similar but far less sophisticated effects can be produced with 2D software, using warp transformations and playing with layer opacity.

Far right: Inspired by the result of a program written by John Maeda to simulate a work by American artist Kenneth Noland, this illustrates the use of "negative space." Glimpses of the image obscured by the monochromatic "tiles" encourage the viewer's imagination to interpret what is hidden.

Below: Traditionally, photographers have put a lot of effort into avoiding a blurred image, and image manipulation software contains many filters to sharpen poorly focused originals. For the digital artist, the Blur filters offer great scope for creativity. Applying an exaggerated motion blur can produce very dynamic results. Experiment by mixing the blur options, a Gaussian blur followed by a Radial zoom blur can turn a dull static image into a wild abstract.

Right: A simple but impressive linear effect can be created by copying a thin vertical slice of an image, and then "stretching" it on the horizontal axis by using the horizontal scale command at the maximum percentage, or by dragging the picture box horizontally by hand. The image has been further distorted to create perspective, then duplicated, and the copy "flipped." Finally, the opacity of the overlying layer has been reduced to reveal the layer beneath.

2.6

Pictures with pixels > Pixel art

The origins of pixel art date back to the early age of computer gaming, when the tiny memory available had to be used with optimum efficiency, especially where graphics were concerned. This resulted in low resolutions and few colors, so each pixel had to be positioned for maximum impact. Until recently, this illustrative style was forced into the background by the current obsession with super-realistic 3D; but intricate, hand-built, pixelated graphics have now found a cult following among some of today's cutting-edge illustrators and designers. With bright colors, clean lines, and painstaking attention to detail, pixel art has become a distinctive contemporary illustration technique.

Modern bitmap applications were developed to do just the opposite–to eradicate the pixel–so the tools provided are often of little use. Anti-aliasing options must be turned off, as this has the effect of disguising the pixels. Even then, the results are often unsatisfactory because pixels are not evenly distributed. The only fail-safe method to achieve a clean effect is to place each individual pixel with the pencil tool. As this process is time consuming, areas previously drawn are often copied and duplicated on separate layers.

Re-sampling or resizing artwork involves "interpolation," which breaks down the pixel structure. Never reduce or increase the resolution unless by whole multiples of 100%, and always ensure interpolation is disabled when re-sampling by selecting "Nearest Neighbor" in Photoshop.

Opposite: *Pixel City* by René Hernandez Miranda (www.pixelfreak.com). Highly detailed isometric cities and landscapes are common subjects for the pixel artist. The style is based on technical drawing used widely by architects. In spite of the millions of colors supported by modern computers, restricted color palettes are often used, a common choice being the "web-safe" palette, a nearly obsolete set of 200 colors that were originally designed to display correctly in any web browser.

Below: Icon-sized pixel characters are almost an art form in themselves. Many pixel artists create icons for themselves. The icons become their "signatures" and are used as distinctive identifiers on chat and bulletin board sites. Often, the icons are simple GIF animations, enabling facial expressions and limited movements.

Above: A popular genre for the pixel artist is isometrics—a form of perspective usually used in technical drawing. Isometric drawing is based on lines drawn at angles of 30° and is used to simplify the representation of 3D objects in 2D artwork. However, when a 30° line is bitmapped, the aliasing effect breaks them into an untidy sequence of one and two pixel segments. For a neat appearance, pixel lines must be drawn at an angle of 22.5°. This forms a line of evenly stepped two-pixel blocks, whereas a 45° angle would be composed of single pixels. The result is not a true isometric, but looks very similar. Once the lines have been meticulously created, ensuring each pixel touches the next, areas enclosed by pixels can be simply colored using a paint bucket tool.

Above: PixelDam is a large scale virtual world, featuring complete city neighborhoods. Users take a whole block and create entire buildings, designing the way they look both inside and out. This follows in the heritage of Maxis' SimCity— probably the best-known example of the game industry's early virtual worlds. It pioneered the isometric 3D view that has since became the hallmark style of pixel art.

Left: One name synonymous with pixel art is Eboy. Eboy are a group of Berlin and New York-based artists who have taken pixel illustration to new limits, from intricate cityscapes to imitations of traditional artistic styles. They even play with semi-realism, as in this portrait.

Today, there are a number of online virtual worlds that employ the pixel-art style to create online communities. They allow users not only to create a character for themselves (controlling its appearance, clothes, accessories, etc.) but also to create rooms, or design and construct buildings where the characters live. Mostly, these are made from a kit, but in some cases original pixel art can be uploaded.

Above: **An Xbox gamer on the cover** of *Game State*, a magazine for US developers. Gary Lucken is one of the UK's leading pixel artists. His experience of working in the graphic-design department of a videogame company and his enthusiasm for the retro days of the Super Nintendo are among the influences that have led him to develop his personal pixel art style.

Left: **Another of Gary's detailed** pixel illustrations.

Right: **Gary Lucken's pixel characters** almost all originate from simple sketches. This row of figures was created for display at small scale, so there's less detail in the coloring and the shading.

Part 3

taking a line
for a walk >

Left: This work started life as a single wavy line drawn using vector software. Several duplications were performed and "grouped" to create a single shape that could be transformed using the "Free Distort" tool (see pages 92–93). The process was repeated on a second line with the color changed to blue. To make the effect softer, a "glow" was created by adding a slight blur to each group.

3.1

Taking a line for a walk > Using vectors

In the 1920s, the artist Paul Klee defined the process of drawing as "taking a line for a walk," and this metaphor is just as relevant for the digital age. Vector drawing applications make light work of complex linear creations with the use of Bézier curves. Once the line or shape has been drawn, single keystrokes can be used to perform multiple duplications or color variations. On-screen palettes manage every aspect of the drawing with infinite variables including the "stroke" and "fill." When repeated, rotated, and overlaid, a simple line can appear to physically vibrate, playing confusing tricks on the eye. These optical illusions resembling watered silk are known as moiré patterns.

Games can be played by altering the line thickness and direction. Collections of shorter lines may be grouped, duplicated, and then distributed across the page using the alignment tools, creating what appear to be the most intricate random patterns. Three-dimensional forms can unexpectedly take shape. These effects can often be accentuated by the use of contrasting color combinations, not only for the lines themselves, but by adding unexpected background hues.

The first step in mastering any vector drawing application is to create smooth curves with a pen tool. Continuous curves, or paths, are composed of Bézier segments, each moving on from the last one's end point. Two "handles" on either end of

a parallel line that is attached to the point control the action of the curve. This is known as the curve point. The handles can be moved or dragged independently using the cursor to change the shape of the curve. This can take a bit of time to get used to, but is fundamental to vector drawing.

Using the software's pen tool, draw paths by clicking with the mouse wherever you want the next point. If you click and let go, you add a point with no handles, drawing a straight line. If you move on, clicking repeatedly, you create a series of attached straight lines. When you click and keep your finger on the mouse button while dragging the cursor away from the point, you create a curve, and two symmetrical lines with handles will be drawn out of the point. If you click the next point without dragging, a point with no handles will again be added. Continuing this way, you can draw smooth curved lines or shapes with acute angles, or a mixture of the two.

The rules to remember are: click + click = straight line, drag + drag = smooth curve, drag + click = broken curve. To finish the path you must either click on your original point–creating a "shape," also known as a closed path–or change to a different tool and click away from the path to leave it open.

Grids and guides provided by the software can be used to help position the points of the path. You can set the size of the

1. 2. 3. 4.

1. Click once to locate the first point.
Move the cursor and click again.
If you let go of the mouse button,
you have made a straight line.
2. If you hold the button down and
drag sideways, you pull out a handle,
making a curve. A handle also appears
symmetrically opposite the point.
3. Let go and then click a third time to
form the second part of the curve.
4. By clicking on the second point again
before you click a third, you lose half
the handle and create a corner point.
5. An open path. Each curve point can
be adjusted after the line is drawn.
6. A closed path, forming a square.

grid to suit your drawing. Horizontal or vertical guide lines can
be positioned anywhere you want them, and locked in place
as desired. Some programs will even allow you to convert a
drawn path into a guide. Snapping guides and "smart" guides
are also useful options. A point will automatically "snap" to
any position on the grid it passes, or the grid will provide a
pop-up guide indicating when a point is parallel to or at a
specific angle to one already drawn. These aids make light
work of accurate alignment of lines and shapes.

 Once the principle of drawing a Bézier line is mastered
there is really no end to the options provided by processing
power. Computers excel at repetitive work, and duplication
and "step and repeat" functions in graphics programs can be
performed by keystrokes. Grouping multiple lines and then
distorting by stretching and twisting is straightforward. It's
worth remembering that when a group of lines is distorted, the
weight of the stroke or line thickness will be affected. After
performing any transformation, select the group and reset the
line weight, usually measured in "points" (like text) or inches.

Right: Using a pen tool, draw a curving
line. The "waves" can be adjusted using
the Bézier "handles" at each anchor
point. Use the palettes to control the
color and weight of the line.
Once you are satisfied with the single
stroke, select and duplicate it. This can be
achieved by a step and repeat action, or
simply copying and pasting. The lines can
then be aligned horizontally or vertically
and distributed with uniform spacing
using the Distribute Objects tools.

These grouped lines have been
put through the wringer. Distorted
by stretching, rotating, and "free
transforming"—treating the group
as a single rectangular object with
a control handle at each of the four
corners. The handles can be pulled
independently in any direction.

3.2

Using vectors > Strokes and fills

Every vector path must have what is known as a "stroke" and a "fill." The stroke determines the appearance of the path itself. This may be a simple line of any given thickness in any chosen color, or one of many options from the stroke libraries included with the vector software. The stroke may also be set to "none," making the line invisible. Various dashed and dotted options are usually available and line ends can be applied in the form of circles, squares, or arrowheads.

The areas inside the path can be filled with a color, pattern, or texture. If the path is "closed," this will create a solid, filled shape; if not, just the areas created inside a boundary will fill. Gradient fills blend smoothly from one color to another either linearly (from side to side or top to bottom) or radially (from the center to the outer edges). Gradients may be composed of any number of colors, and the position and the softness of the blend between each are infinitely controllable. In the gradient tool box, colors are added by clicking the desired position on a horizontal bar and then selecting a color from the palette. Many patterns and textures are supplied with the software or you can create your own. In fact, any vector or bitmap image can be placed within a shape to fill it.

The relative position of any fill placed in a vector path remains constant; even if the shape is moved or modified, the fill will not distort to match its shape.

Opposite: **This image has been built with straight lines randomly drawn with a pen tool. A simple colored stroke has been applied. The group of lines has been copied and rotated and a different stoke color added. The process is repeated, each time selecting a new stroke color. The small circles filled with a solid yellow were duplicated several times and then positioned on different layers of the picture, some between the line groups, some on top, or in front of the lines. The result has a 3D quality.**

Above: Most vector software, such as **Adobe Illustrator, includes libraries of strokes and fills. Some of them are worth investigating. Texture fills like Scribble Effects** (top) **can be useful. The collections of strokes range from various pencil and brush effects to the bizarre—food, flowers, household implements, and even sporting figures.**

a)

Some examples of the standard strokes and fills included with Illustrator.

The "target" was made up by selecting the Circle tool and specifying an equal height and width. The circle was copied, duplicated, and the scale reduced by 90%. This was repeated several times, then the circles were centrally aligned.

This page, clockwise from above right:
a) With the stroke set to "none," each circle was filled with a complementary solid color.
b) These fills were selected from the "Scribble Effects" and "Texture" palettes.
c) These strokes are from the "Artistic" brush libraries.

Opposite page, clockwise from above right:
a) Two groups of circles, the first stroked with the "Fude" brush, overlaid with a set stroked with "Matches" from the Household Objects library.
b) The "Bubbles" stroke from the Decorative Scatter collection.

c) A wreath stroked with "Rose" from Foliage > Floral.
d) A mixture of strokes and fills. Remember the Spirograph?

b)

c)

a)

b)

c)

d)

Star Wars meets *A Space Odyssey*.
Using the same group of concentric circles, a 40pt "Galaxy" stroke from the Illustrator stroke library has been applied with cyan as the color. This has been duplicated, rotated, and recolored with magenta, and the opacity has been reduced by 10%. This was then duplicated a second time, colored white, again rotated on the same axis, and the transparency reduced further by 30%. This "interstellar explosion" then started to take shape. The advantage of computation means this process can simply be repeated as many times as you want until you are satisfied with the result. May the Force be with you.

Taking the "target" group of circles again; here the alignment has been changed to create a more three-dimensional effect. Copying and rotating the groups produces very dynamic results.

Far left: **These paths have been stroked with a Decorative Scatter "cube" over a solid fill background. The weight, or thickness of the strokes has been varied to give the impression of depth.**

Above left: **Keeping the groups the same size, but rotating each on a central axis, gives an impression of movement. Here an Artistic brush stroke has been applied.**

Above: **Another "Decorative Scatter" brush made of small circular elements outlined with color, superimposed over a gradient fill background.**

Left: **Varying the size and direction of the concentric rings, strokes of solid color are applied over a radial gradient filled background.**

Below: Playing with groups of straight lines and flat colors can produce vibrant results. By applying a "free distort" or simply duplicating and flipping the direction, unexpected shapes can be formed. Look at the "Samurai," below left.

Right: The "pyramid" appears to have three-dimensional form. Single straight lines in muted shades are duplicated numerous times, then "cropped" by intersecting with a triangular box. The grouped lines are subsequently rotated and aligned to create the four faces. The linear background is created in the same way by drawing horizontal lines, coloring them, duplicating, changing the thickness, and distributing them randomly down the page. Groups of lines are duplicated several times and positioned using a vertical alignment tool to gradually build the image, continuing until the entire page is covered.

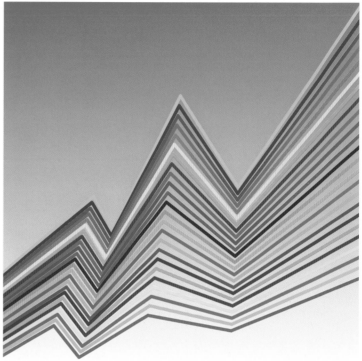

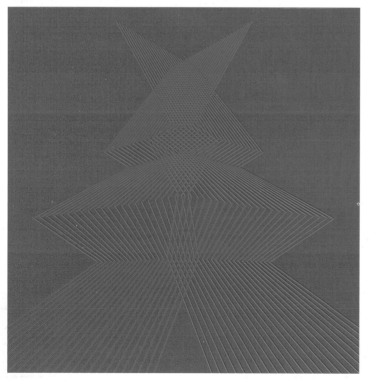

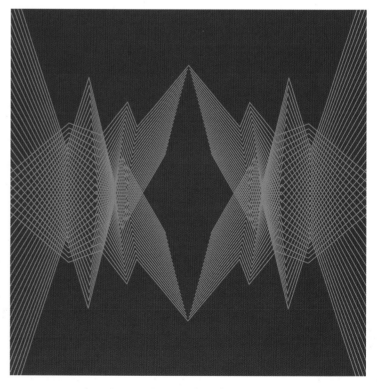

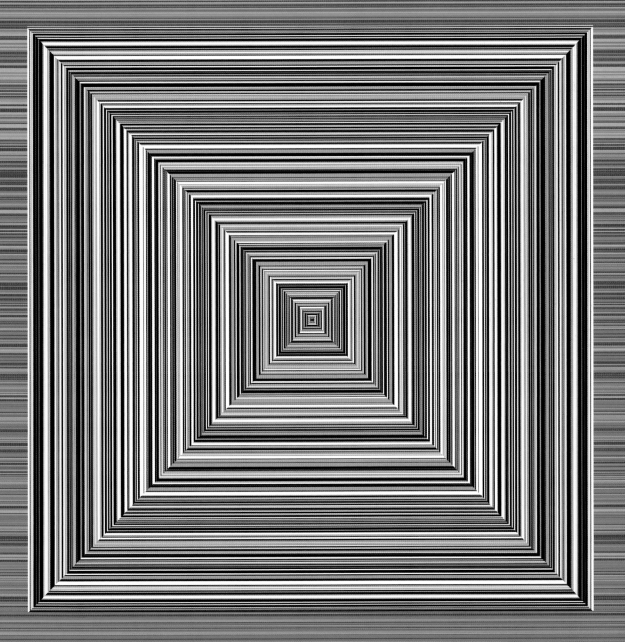

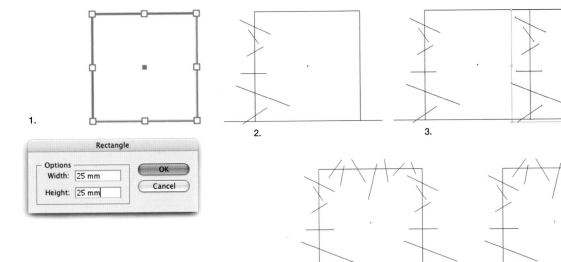

1.

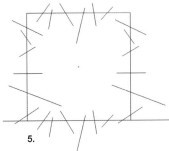

2. 3.

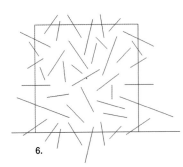

4.

5.

3.3

Using vectors > **Making custom fills**

Even though there are libraries of fills, strokes, and textures included with most vector software packages, it's always more rewarding to create your own. Illustrator has an option to convert a selection into a repeating pattern, or texture, which can be used as a custom fill for any shape.

6. 7.

8.

Left: If you leave your custom fill "tile" with no background color, you can place a transparent shape filled with the new pattern (or patterns) over another shape—containing an image, library fill, or custom fill—building complex visual forms.

1. Select the Rectangle tool and create a square the size you want your pattern "tile." It is usually best to keep the size to between 1–2 inches.

2. If you want a fixed background color, fill the square now. If you want more flexibility, leave both the fill and the stroke as "none." Start by drawing lines or shapes that intersect, or cross, only the left side of the square.

3. Select these lines and the square, position the cursor on the lower left side of the square, and hold the Shift+Option/Alt keys while dragging the selection to the right. When the cursor hits the lower right side of the original square, release the mouse and keys. This operation will copy the selection and place another square next to the first. To position this duplicate

easily, "snap to guides" should be selected. Delete the second square, leaving the texture elements in place.

4. Now, draw the elements that will only intersect the top of the "tile." Select all and repeat step 3, this time dragging down to duplicate the selection below the first square.

5. Delete the third square and all elements that are below it.

6. Now draw in elements to fill the center of the square.

7. Color the elements. You can use as many colors as you want, but remember that elements crossing directly opposite sides of the tile must be the same color.

8. Select all, and go to Edit > Define Pattern. Give the texture a name and click OK. The pattern is saved to the Colors palette, and can be used as a normal fill.

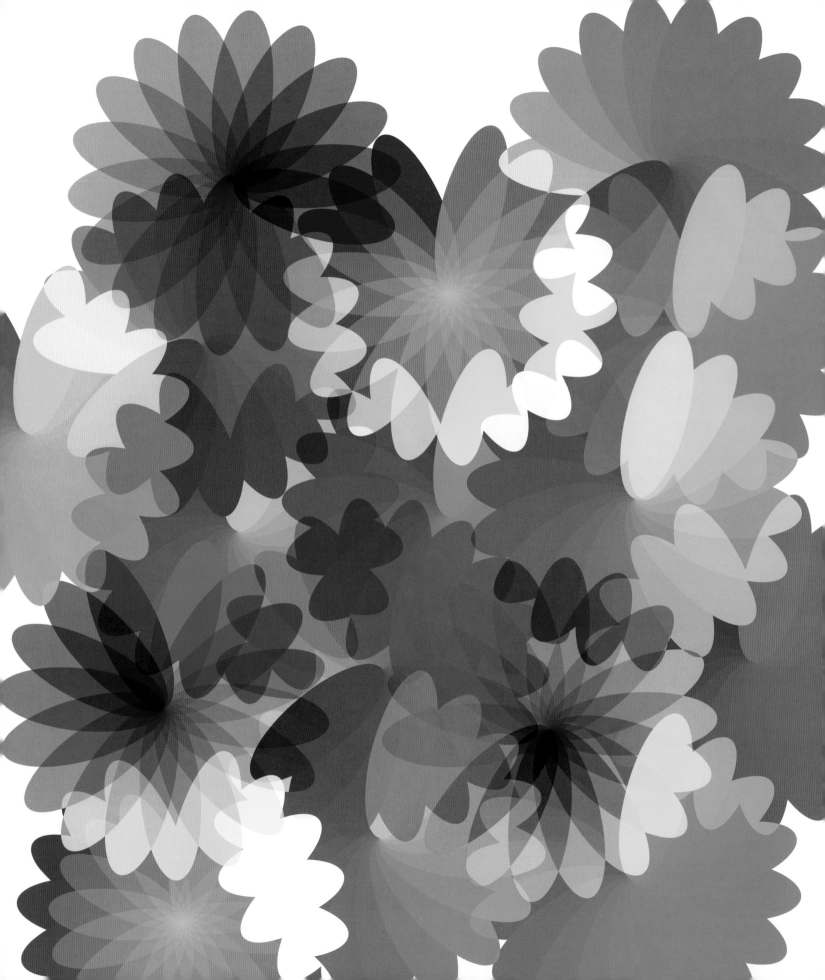

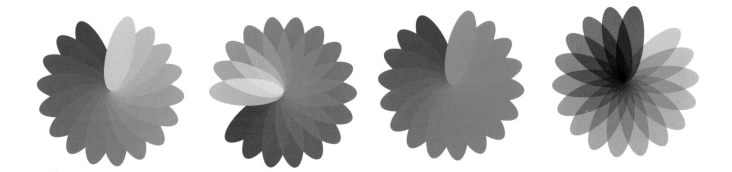

3.4

Using vectors > **Making shapes**

Vector software makes the process of creating shapes quick and easy. Tools are provided to draw basic rectangles, ellipses, and polygons by simply clicking and dragging the cursor. If you want a more formal arrangement of shapes, the size can be pre-specified by keying in the desired dimensions. Symmetrical shapes, such as squares and circles, are automatically created by holding down the Shift key while dragging.

Individual shapes can be grouped, duplicated, and combined to give the image further depth. Alternatively, a pathfinder function can be used to intersect, combine, trim, or divide the separate elements while the transparency blending modes, though less sophisticated than the bitmap equivalents, will make overlapping colors blend together or appear transparent. By mixing and matching, varying degrees of complexity can easily be achieved.

Illustrator includes a selection of distortion filters—with names such as Pucker & Bloat, Twist, and Tweak—that can be used to instantly transform regular shaped objects. There are also a number of distortion tools; by simply holding or dragging the Scallop or Crystallize tool, for example, on the path of a shape, the program randomly distorts the path, automatically generating new vector handles and path segments that appear to take form almost organically.

Above: Vector drawing software incorporates many tools to simplify the drawing and coloring of shapes. With a rectangle or ellipse tool, click and drag to create randomly sized and proportioned objects. Fills can be applied by picking a color, gradient, or custom fill chosen from one of the many palettes, and the objects arranged by eye or by using alignment functions. Unlike bitmap programs, vector shapes can be positioned with great accuracy; step and repeat commands, such as Transform and Transform Again, can duplicate the shape on any desired axis by using single keystrokes; and transparency blend modes can be applied to individual elements or groups of shapes.

The pioneers of computer graphics wrote programs that enabled the machine to randomly draw and place simple shapes. The beauty of the resulting images lies in the fact that they were created purely by the algorithmic process.

Similar effects can be accomplished by hand, using the transform functions included in vector software. As the duplication of objects can be performed by keystrokes, the process of experimentation is easy. Of course, these images are not true "computer art," and to make them we are taking a retrograde step, but the static simulation of animated objects can produce interesting results.

Right: Crystalline pattern effects produced by repeating semi-transparent geometrical shapes on a single axis using a fixed angle of rotation for each step.

Left: The effect of "stroking" the bounding path of a series of horizontally aligned and vertically spaced colored rectangles using Illustrator's Crystallize tool.

Below: Illustrator includes a selection of distort and transform filters and brush tools. Here, a collection of colored rectangular shapes have been treated with the Pucker & Bloat filter.

Macromedia Flash is a vector graphics program created for animation on the web. Over its lifecycle it has evolved a fully-fledged scripting language, ActionScript, that allows complex, programmed animation and interaction.

All of these images were created from simple vector shapes that were iterated, either according to predefined rules or with random functions, to produce more complex forms. The majority of them are stills taken from animations.

Masters of the art > Brendan Dawes

Brendan Dawes is Executive Creative Director for magneticNorth, based in Manchester, U.K. On his personal site, brendandawes.com, he creates digital work inspired by the analog world around him. While a lot of his work is centered around interaction design, many of the projects also include prints, motion design, and hardware-based hacks.

Taking things apart and putting them back together in unconventional ways is a recurrent theme in his work. Inspired by jazz musicians such as Thelonious Monk and graphic pioneers like John Whitney, Brendan believes that as everything in nature is numbers, those "numbers" can be twisted and shaped into new interesting forms, be that sound into vision, or creating software that takes DVD movies and displays them in new ways. Brendan also likes to fuse the analog with the digital—from using Play-Doh as an interface to QuickTime video, to wiring up a Snow Globe to control a photographic slideshow. It's this mutation of the analog and digital worlds that makes Brendan want to constantly explore the relationship between humans and machines.

Left and below: Creating unique visual interpretations of songs. A piece of software was written that used nothing but the frequencies of the music to create non-digital looking prints.

Right: Cinema Redux. Distilling a film down to one single image to create a kind of DNA for an entire movie. A frame of the movie *Hero* (© Yimou Zhang, Beijing New Picture Film Co./Elite Group Enterprises) was sampled every second, with each row representing one minute of footage.

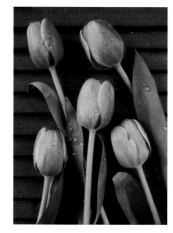

The original bitmap image

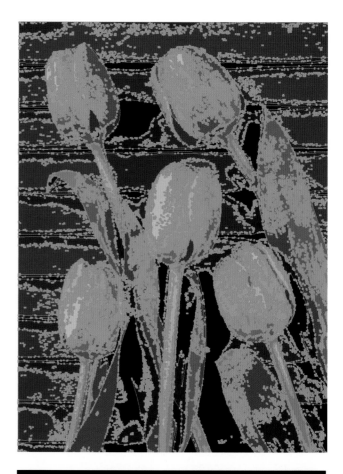

3.5

Using vectors > **Converting bitmap to vector**

Until recently, with the introduction of Adobe Illustrator CS2, dedicated software was required to make a successful conversion of a pixel-based image into vector paths. Thankfully, Adobe has seen fit to incorporate a vector filter into the latest version of the application, known as Live Trace.

The level of detail and the number of colors traced can be finely controlled either by using a preset selection to automatically do the job for you, or by setting the parameters individually. The trace is created by the program first identifying a color, or range of similar colors, and then creating a path to contain it. Preset options include Photo High and Low Fidelity modes, which generate the number of paths to create a vector representation of the original bitmap image. The tracing can be altered, edited, or the options changed at any time before hitting the Trace command that creates the final vector artwork. The paths can then be individually manipulated just as with any other vector file.

Simplified monochromatic artwork can be made using a "Threshold" option that specifies the values for generating a black and white result from the original image. Pixels lighter than the set value are converted to white, and pixels darker to black.

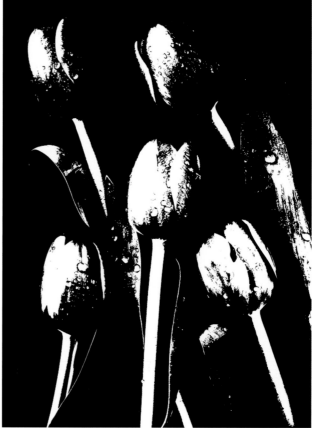

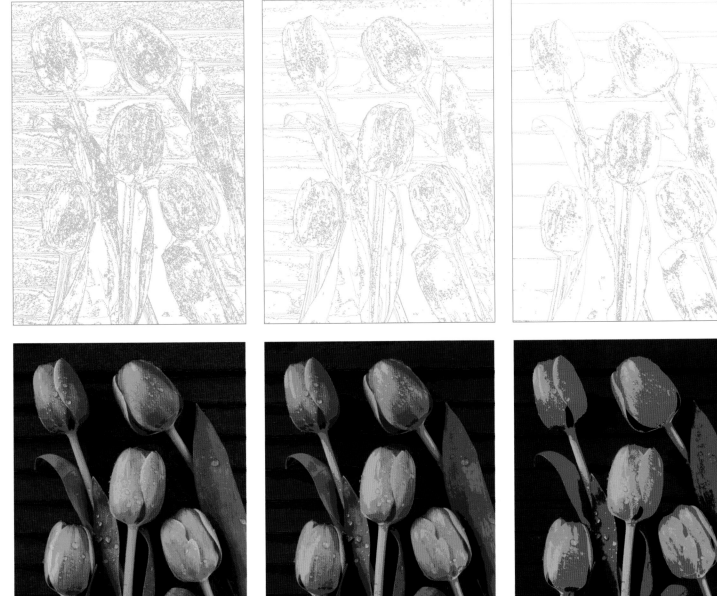

Left: With the parameters set at Photo High Fidelity mode, the maximum number of paths are generated, producing vector artwork of near photorealistic quality.

Center: **Photo Low Fidelity settings** generate fewer paths, but still provide an acceptable result.

Right: **The number of colors used for the trace can be set to automatically generate degrees of complexity, or a new swatch library can be created that contains only the colors you want to use. Here, the palette has been limited to sixteen colors.**

3.6

Using vectors > Digital graffiti

Abhorred by the city authorities, graffiti has been a phenomenon of urban life since the birth of spray can street art in the 1970s. Most graffiti artists are members of a hard-line counterculture, with its own style, language, codes, and rules of engagement. But their work has had a powerful influence across the whole spectrum of contemporary design.

Today, the design world takes inspiration from the culture of street art and has absorbed its look and feel–graffiti lettering styles and designs have become mainstream, recognized as part of our everyday culture. We see them on advertising posters, in magazines, on music CDs, product packaging, websites, T-shirts, and fashion logos.

You no longer have to get out on the street with a bag of spray cans–graffiti-inspired art can be easily rendered on your desktop with processor and software.

Left: The anarchic graphic styles of the street artist can be mimicked in the privacy of your own home. Using both vector and bitmap drawing tools with all the available stokes, brushes, and fills, simulated spray can art can be calmly manufactured on the computer. Letterforms can be drawn freehand, outlined fonts can be distorted, or a hand drawn sketch can be scanned and used as a template. The explosive effects are created by applying Pucker & Bloat distortions to geometric shapes drawn on an overlying layer. Vertical stroked lines simulate the dripping wet paint.

Right: Some of the original street artists, attracted by the massive and receptive audience of the Internet, exchanged spray cans for software. 123klan was started in 1992 by two graffiti writers, Scien and Klor, from Lille, France. Their distinctive, personal style rapidly got them known and respected, and they staged events and performances in France, Holland, Italy, U.K., U.S.A., and the Far East. In 1993, they bought their first Mac and began experimenting with digital graffiti pieces. Now married, their current work mixes graffiti, illustration, and graphic design.

Marius Watz discovered the computer at an early age and immediately found his direction in life. In 1993 he moved from Computer Science studies to creating graphics for raves, using his programming skills to create organic shapes in 2D and 3D. His work is concerned with the algorithmic generation of form, whether still, animated, or interactive, and marked by deliberate excess in terms of color and form.

Watz currently considers himself an ex-designer. In recent years, he has abandoned traditional commercial design work for personal projects dealing with generative form. The notion of drawing machines, i.e. software pieces, that model drawing processes has become central to Watz' work. He often uses a drawn-out time span to underline the drawing process. In 2003 Watz completed *Drawing Machine 1-12*, an art commission for the web site of the Norwegian Government. In this case, twelve drawing machines drew one image each over the span of two months, so that the project ran for two years in total.

Watz has exhibited widely, most recently at *Onedotzero9* (London), *Territoires Electroniques* (Aix-en-Provence), *Electrohype* (Malmö), *Sonar* (Barcelona), *Virtual Frame* (Vienna), and *Manyfacture* (Reykjavik). He also performs live visuals for music with custom-made software. Clients include generative works for Nike, Nokia and the cell phone company "3".

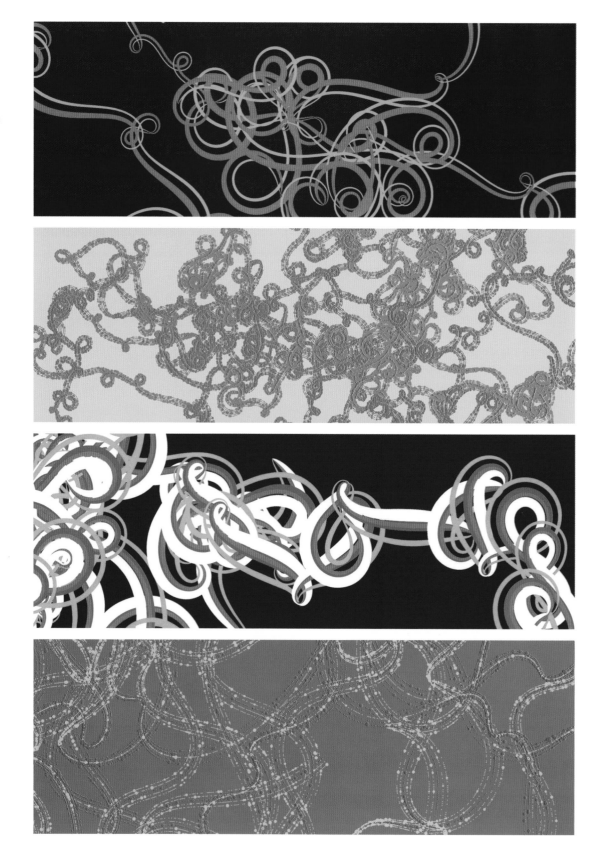

ElectroPlastique 1 (2005)

A four-screen temporal composition for the *Territoires Electroniques* festival 2005 at Le Fondation Vasarely in Aix-en-Provence. The starting point was the work of Victor Vasarely, the famous father of Op-Art. "I have always been inspired by his work with the transformation of shapes and grids, as well as his wonderful use of light and color to create depth. His Plastic Alphabet and the programs he created for his images represent a generative approach to form that is strict and yet organic."

In *ElectroPlastique 1* a regular grid is deformed and then used as the basis of a series of organic abstract systems that evolve over time (five minutes). Due to the panoramic format of the four-screen projection, the impression is much like a landscape. In the end the grid is exploded and disappears, hinting at a non-cartesian vector space.

Sound by James Welburn. Built with Processing and Java. Thanks to Eric Dalbin for the invitation to do the project.

Left: *System_C* is a time-based drawing machine, a software system for the creation of rule-based images. Several autonomous agents move over a surface, making marks as they move, as a realtime two-screen projection.

The drawing process is modeled on a simple kinetic system. Each agent has a speed and direction that both smoothly change for every step it takes. When the speed or rate of rotation exceeds the minimum or maximum constraints, they start reversing so that their values tend toward the other extreme, causing a subtle oscillation between values over time. Different values for the constraints result in visually different but recognizably related images.

Each image takes an hour to complete. Once an image is done, the surface is cleared, the drawing system is set to a randomized initial state and the drawing process starts over.

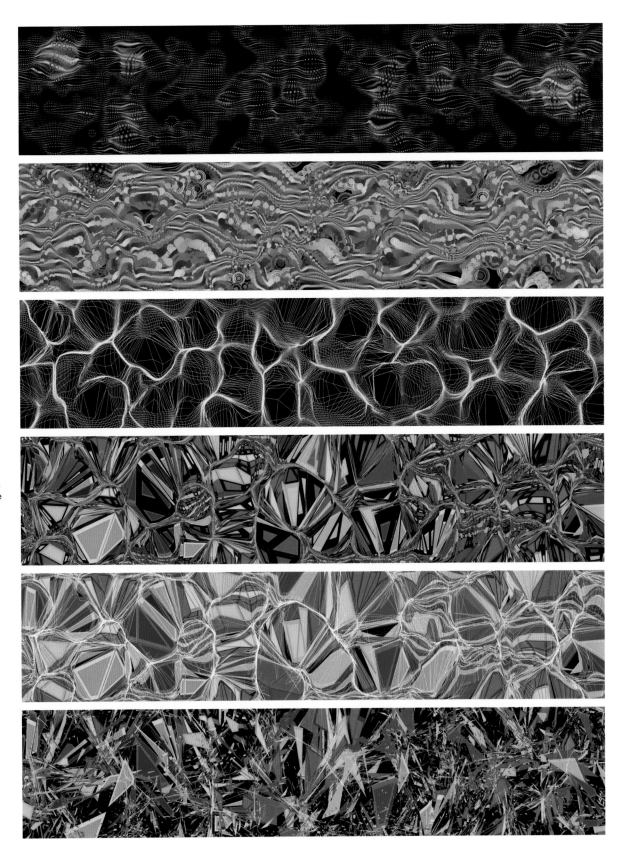

Part 4

painting
with letters >

Randomly typing, sizing, and coloring letters in a word processing application, using transparent "text boxes" for each character. The boxes can be independently moved and scaled and placed one over another to build intricate patterns.

4.1

Painting with letters > **Creative writing**

For a graphic designer, the physical form of the written word is almost as important as its content. The choice of typeface and the way text is arranged on a page can make a vast difference to the message it is communicating. As type can be created and manipulated in virtually any computer application, it is a perfect creative "tool" for the digital artist.

With so many different styles of type now available to the average computer user, the letterform has become something of an art form. The way type is used and displayed has changed drastically–for better or for worse–since the desktop publishing revolution of the 1980s. Our eyes are more accustomed to seeing experimental type treatments, and accordingly, it is the clever manipulation of type that attracts the most attention.

Word and letterforms can be used to draw and sculpt in their own right, regardless of their actual meaning. Of course, when the visual presentation is combined with meaningful content, a powerful message can be delivered.

Type can be used to create eye-catching patterns by playing with the size and color. Words can be duplicated hundreds of times to create textured backgrounds or even arranged to form shapes and pictures. More sophisticated software will enable text to be typed along curved lines or circular paths. Letterforms might be filled with scanned pictures or artwork (look at the chapter introductions in this book), or twisted and distorted to become abstract expressions.

Digital letterform information is stored in both bitmap and vector forms. Bitmap data is used by the operating system to draw characters on-screen and a scalable vector outline known as the PostScript file is used for downloading to the printer. Adobe introduced the PostScript page description software to instruct printing devices to produce accurate letterforms and graphics at any required size.

As PostScript fonts have a vector outline, any character can easily be converted to a vector shape. Of course, once converted, it is no longer a character and so can't be edited with a text tool. A vector letter can be treated as any other vector shape. PostScript type created in both bitmap and vector software can also be rasterized to make use of the available manipulation filters. Once a letter is rasterized, it loses its outline and so again cannot be changed using a type tool.

The simplicity with which type can be set, colored, sized, distorted, twisted, or stretched in even the most basic word processing application instantly gives the aspiring digital artist a virtually unlimited array of creative possibilities.

Left: A word or phrase can be typed in a word processing application, then copied and repeated several times. The size (known typographically as "point size") can be altered to create lines of different weight, and individual words colored to create a powerful graphic image. This piece, based on a design by John Maeda for a cover for the *New York Times Magazine*, was created in Illustrator using color blends and the distort filter.

4.3

Painting with letters > Letterforms

The selection of digital letterforms or fonts currently available is amazing, and font designers are constantly adding new styles and families. There are almost infinite permutations to the shape of the twenty-six letters of the alphabet. As the architect Mies van der Rohe once wrote, "God is in the detail." There are at least twenty-two different terms for the individual parts of a single character of type. They range from the "x-height," "descender," and "serif," to the "spine," and "ear." Together, these terms allow us to name and describe the elements that make up the design and construction of each letter–thus helping us define what gives a font its special character, and what distinguishes one font from another.

Perhaps the most noticeable difference between fonts is that some are "serif" while others are "sans serif." Serifs are the short strokes at the end of the stems, arms, and tails of a letter. Even serifs themselves have a wide variety of different forms: beaked, bracketed, hooked, slab, spur, or wedge.

Fonts generally come in "families." These are essentially variations on a theme, with each face in a single family sharing the same design characteristics. The most common families are: roman, italic, light, light italic, bold, and bold italic. Roman faces are upright, italic faces are sloping, light faces have thinner strokes than normal, and bold faces have thicker strokes than normal. Of course, there are many further variations: condensed, ultra light, ultra bold, heavy, fat face, and so on.

If this wasn't variety enough, the technological changes of the last twenty-five years or so have brought type into the digital world. Fonts are now designed, used, and output on computers. Type is no longer physical. Each letter no longer exists as a solid block of metal. This means that the possibilities for further manipulating letterforms are virtually unlimited. They can be squeezed, stretched, flattened, elongated, twisted, twirled, inverted, or otherwise distorted in every imaginable way. And they can be colored, textured, patterned–and even animated.

There are many traditional rules that are supposed to limit the way we present typographic information on a page; for instance–in body copy, serif type is more legible than sans serif, and headlines set in all caps are less legible than those set in upper and lower case. Smaller pieces of information sometimes need to be made more interesting, or they will be missed or forgotten. For the digital artist using type as a "medium," these rules can be forgotten. Play as many tricks as you like with scale, position and shape. Set type vertically or diagonally instead of horizontally. Run it along flowing, irregular lines to create patterns on the page. Use color and texture as imaginatively as you can. Type can be combined with illustrations, photographs, and other graphic elements, or used to create pictures and images from the letterforms themselves.

The range of digital fonts available is breathtaking. Though many downloadable fonts can be used freely, be aware that font usage in general is covered by strict licensing rules that prohibit the purchaser supplying fonts to a third party such as a print company.

The term font was originally spelled "fount." It derives from the type foundry, where individual letters were cast from lead alloys to form metal blocks, and then combined with one another by the typesetter to build up words. Blank metal "slugs" were inserted to separate words, and sometimes to add a little extra space between individual letters.

Most fonts are designed either for setting large quantities of text (such as a book) or for decorative display. In the case of the former, legibility is vital. In the case of display, there's more scope for experimentation.

with type text effects drawing with type. text effects drawing with type- text effects drawing with type. text effects drawing with type. text effects drawing with type text effects drawing with type text effects drawing with type text effects drawing with type text effects drawing with type text effects drawing with type text effects drawing with type text effects drawing with type text effects drawing with type text effects drawing with type text effects drawing with type text effects drawing with type text effects drawing with type text effects drawing with type text effects drawing with type text effects drawing with type-text effects drawing with type-text effects drawing with type text effects drawing with type text effects drawing with type text effects drawing with type text effects drawing with type text effects drawing with type text effects drawing with type text effects drawing with type text effects drawing with type text effects drawing with type text effects drawing with type text effects drawing with type text effects drawing with type text effects drawing with type text effects drawing with type text effects drawing with type-text effects drawing with type text effects drawing with type text effects drawing with type text effects drawing with type text effects drawing with type text effects drawing with type text effects drawing with type-text effects drawing with type text effects drawing with type text effects drawing with type text effects drawing with type text effects drawing with type text effects drawing with type text effects drawing with type-text effects drawing with type text effects drawing with type text effects drawing with type text effects drawing with type text effects drawing with type text effects drawing with type-text effects drawing with type-text effects drawing with type text effects drawing with type text effects drawing with type text effects drawing with type text effects drawing with type text effects drawing with type text effects drawing with type text effects drawing with type text effects drawing with type text effects drawing with type text effects drawing with type text effects drawing with type text effects drawing with type-text effects drawing with type text effects drawing with type text effects drawing with type text effects drawing with type text effects drawing with type text effects drawing with type text effects drawing with type-text effects drawing with type-text effects drawing with type text effects drawing with type text effects drawing with type text effects drawing with type text effects drawing with type-text effects drawing with type text effects drawing with type text effects drawing with type text effects drawing with type text effects drawing with type text effects drawing with type text effects drawing with type text effects drawing with type text effects drawing with type text effects drawing with type text effects drawing with type text effects drawing with type-text effects drawing with type-text effects drawing with type text effects drawing with type text effects drawing with type text effects drawing with type text effects drawing with type text effects drawing with type text effects drawing with type text effects drawing with type text effects drawing with type text effects drawing with type text effects drawing with type text effects drawing with type text effects drawing with type text effects draw

Left: A page layout program has been utilized to type and repeat a phrase without punctuation. The text boxes are duplicated, offset over one another, and the color tint varied for each. The final message is typed along a curving line.

Below: Based on an experiment in typography by German designer Hans-Rudolf Lutz, these words, created in a vector program and converted to outlines, were overlaid with concentric circles. A "divide" filter cut the path elements and the resulting "rings" were turned by degrees to produce configurations of the fragmented letters.

Right: A single word is duplicated many times, each tilted or "rotated" by varying degrees. Using an enlarged letterform as a template, the individual words are randomly placed to build a representation of the single letter. The "template letter" is subsequently removed. The same method has been used to create the background texture, the individual words duplicated and their position shifted in groups to speed up the process.

Divide Divide · **&Spin &Spin**

Opposite: **Color can play as important a role in design as the letterforms themselves. Here, the letters are used merely to create the composition. Converted to vector paths and filled with solid color; the transparency blending modes have been adjusted to allow the colors to interact.**

This page: **In this simple, colorful design the letters have been scaled and cropped to reveal only suggestions of their shape. Surprisingly, they are still recognizable, and we still try to make some sense of their meaning.**

Above: Type as pure visual pattern is taken to the extreme by representing each letterform as a simple block of color. Even though the traditional medium of communication is lost, the brain still tries to make some sense of the pattern as it understands the recognized metaphors of paragraph indents and ragged lines.

This example has been created manually in a basic word processing application by selecting a color for each letter and then changing it to a square "dingbat." Programming code that generates this effect purely by using the keyboard has been explored not only by mathematicians, but exponents of digital art, such as John Maeda and Joshua Berger (with his 1999 Colorface Color font).

Based on the theory of Semiology, which reassessed the relationships of language and objects with the concept of the "semiotic sign," Berger argues that "language is anything that communicates information." Type is no longer solely the letters and punctuation marks that from words and sentences, but "the building blocks of meaning in whatever form that meaning arises—type can now be an image, a sound. Type can be a color."

Below: The meaning of the word has been removed by striking through each line of text with a color rule, leaving only a hint of the actual letterforms. The effect is intriguing, as the viewer is both confused and frustrated by his inability to understand the true meaning, whilst being stimulated by the resulting pattern of color and form.

Below right: By taking the letter and word spacing (kerning and tracking) and the space between lines (leading) to extreme levels, the words themselves become less important than the textural effect.

4.4

Painting with letters > **Numbers**

As all computerized function is based on algorithmic process, it is only appropriate that numbers should be employed by the creative digital artist. Unlike letters, where language can either supplement or confuse the artistic message by the deliberate or accidental formation of recognized words, designs using abstract number patterns are unencumbered by language; they are simply based on the shape and relative positions of the digits. Intricate patterns can be built by repeatedly typing individual colored figures in random positions, or by duplicating number sequences over and again to produce powerful visual effects.

Above: A number sequence typed in a bitmap application can be saved as an image file and imported into any vector shape, in this case an enlarged figure.

Opposite: A complex pattern of duplicated sequences entered in a word processing document. The text box containing the rows of colored numbers has been duplicated and rotated 180°. The addition of a rich solid background color adds a vibrant quality to the design.

This page: **To manually create this freeform explosion of numbers, a sequence was entered on a spiral vector text path. The path was duplicated, and a free transform applied to each copy to alter the individual perspective. The resulting collection has been rasterized and opened in a bitmap application to apply various distortion filters.**

Other images: **Placed in a word processing page, color has been added to both the original grayscale file and the picture box that contains it.**

Opposite: **John Maeda:** "When I first arrived at MIT, I helped the Math Department with some images to help advertise some of their events. I don't do it any longer due to my busier daily schedule, but it was nice to think about the Math Department without having to take any math classes. I chose the theme for one of these posters as butterflies (for my long admiration of these beautiful insects) with numbers for their wings. I like the idea of little numerically winged creatures that fly around in a peaceful way, but I wouldn't want it to happen in real life."

4.5

Painting with letters > Movement

In the never-ending quest to grab the viewer's attention, one of the most significant developments in the rapid evolution of the Web is the ability to create simple animation. The most popular and powerful animation application is Macromedia Flash. Flash has an abundance of easy-to-use type tools, and many options for transforming the resulting letterforms, making it ideal for experimenting with type.

Rather than designing a static image, you are simply creating something that changes over time according to parameters that are easily set, tested, and adjusted. Similar to traditional animation, static "keyframes" are first created that are then added to a "timeline." Flash does the rest by a process known as "tweening"–automatically adding a specified number of frames in between the keyframes–thereby creating a smooth animated sequence. Once the keyframes are done, the rest of the work lies in fine-tuning the movements and adding any frills you desire.

Each letter or word is converted to paths, transformed into a symbol, and assigned to a separate layer—separating each animated element into its own layer is not necessary, but it makes things easier, particularly when the movement of one symbol overlaps the movement of another.

Various shape and motion tweens can be used to create realistic effects. The most important thing is to have a clear concept of what you want to achieve in your head so that you can set the keyframes right at the beginning. From there, any modifications are just a matter of adjusting the shape, easing (the variable speed of the tween—for example, if something eases into a scene, then it might arrive quickly, and slow down as it moves into position), rotation, and alpha settings.

For realistic movies, you should use a frame rate of about thirty frames per second. This can be lowered if your movie is going to be viewed on less powerful computers, but a higher frame rate does not increase the size of the Flash movie file produced.

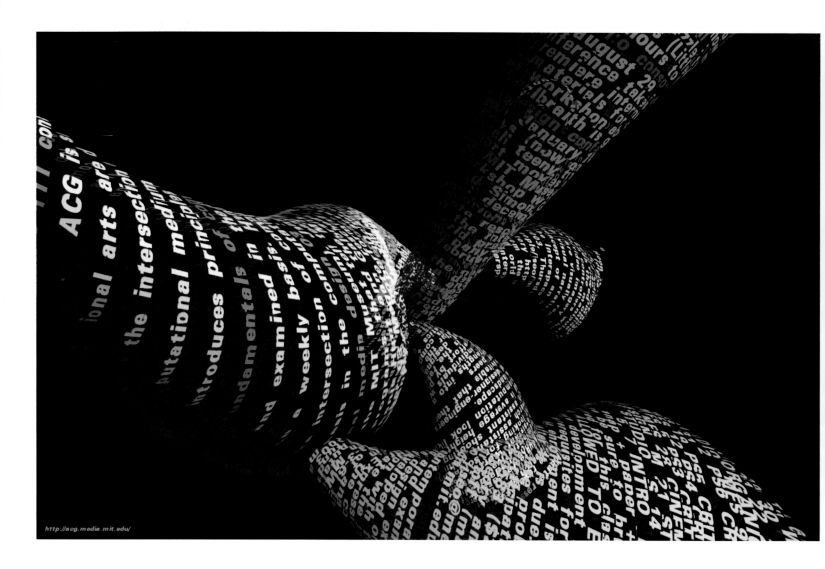

Above: *Experiment in video input*: Scenes from the movie "Fargo" constructed out of letters. The individual letters are chosen based on the brightness of that area of the image, so dark areas might use a small lowercase letter, whereas brighter portions use denser letters, such as a W.

Left: *Tendril*: A web browser that constructs typographic sculptures from the text content of web pages. The first page of a site is rendered as a column of text. Links in the text are colored, and when clicked, the text for the linked page grows from the location of the link.

Below left: *Genome Valence*: Images taken from a visualization of the contents of the book "The Innocents Abroad" by Mark Twain. The program reads the book in a linear fashion, dynamically adding each word into three-dimensional space. The more frequently particular words are found, they make their way toward the outside (so that they can be more easily seen), subsequently pushing less commonly used words to the center. Each time two words are found adjacent in the text, they experience a force of attraction that moves them closer together in the visual model.

"Software is unmistakably no less of an expressive medium or material than any I have worked in before; yet, it was only recently I began to understand how to use it in a purely creative way".

Masters of the art > **Benjamin Fry**

Ben Fry graduated from the MIT Media Laboratory with a Ph.D. in May 2004. His research focuses on methods of visualizing large amounts of data from dynamic information sources. This work is currently directed towards "Genomic Cartography," which is a study into new methods to represent the data found in the human genome.

At MIT, he is a member of the Aesthetics and Computation Group. Ben received an undergraduate degree from the School of Design at Carnegie Mellon University, with a major in Graphic Design and a minor in Computer Science. In addition to his academic work, he has spent time as a designer and programmer at Sun Microsystems and Netscape Communications. His work has been shown at the Whitney Biennial in 2002 and the Cooper Hewitt Design Triennial in 2003. Other work has appeared in the Museum of Modern Art in New York, at Ars Electronica in Linz, Austria, and in the films *Minority Report* and *The Hulk*.

Part 5

graphic
photo art >

An original digital photographic image, opened in Photoshop, has had various levels of Blur applied, followed by a filter called Ink Outlines, to create this painterly effect.

5.1

Graphic photo art > **The power of the dot**

The most widely used incarnation of the digital image is the conversion of photographs to digital format. This may either be carried out at the moment of capture using a digital camera, or converted at a later stage using a scanner. In recent years, the explosion of the digital camera market–providing ever smaller, cheaper devices capable of producing images of ever higher resolution that can transferred to a computer with ease–has led to a general acceptance of the digital photographic image.

For the traditional photographer used to high-definition film and chemical processing techniques, "going digital" has often proved less rewarding. Many believe the depth and subtlety of tone achievable with an image constructed with pixels still falls short of the mark. But for the digital artist, who is less concerned about the true photographic quality, and who wants to use the original image as a basis for creative experimentation, the medium is perfect.

The scope for finding original imagery is huge. If you are not satisfied withyour own photographic skills, libraries of pictures accessible as downloads from the Internet are available. Of course, many of these images are provided by professional photographers, and the right to use them must be paid for–sometimes at great expense. However, there are library services that provide unlimited high resolution images for a one-time fee, which is often far more affordable. Sample images are also included with the image manipulation software package. Photoshop ships with stock images from three libraries covering a wide range of subject matter.

Images direct from a digital camera or supplied by a library will invariably be in a compressed JPEG format (see page 48), and the color mode will be RGB. Before starting any manipulation, you may need to save the file in a different format–PSD or TIFF, for example–to make full use of the available filters. Some digital cameras offer an option to save the image as a RAW file format, in fact some cameras offer only this option. RAW means a file that has not been compressed or modified by the camera. To import a RAW file into image manipulation software will usually require a small "plug-in" to convert it to the program's native file format. A RAW file has the advantage of containing the maximum amount of digital information in a small file size.

Once the digital image is open in the editing software, an endless range of enhancements and alterations can be performed at amazing speeds compared to traditional photographic methods. In fact, many of the achievable effects are not even possible using chemical systems. Color changes, distortion effects, or the ability to make a photographic image appear drawn or painted offer the digital artist unparalleled scope for creativity.

To output a digital image from a commercial four-color printing press, a monochrome, or single color image, must be converted to a series of dots, known a halftone. A color image is converted to four dot separations (cyan, magenta, yellow, and black) that together create a representation of all the colors (see page 50). Exaggerated halftone patterns can also be applied in Photoshop for artistic effect.

Opposite: A halftone image created by converting a continuous tone image into dots of various sizes. The dot can be any shape and size; it can even be a line.

Right: Photoshop's "Halftone" filter applied using a large dot size. Contrasting colors have been added to both the dot and background layers to create a "Pop art" effect.

Far right: The "Color Halftone" filter was applied here to exaggerate the dot. This is not strictly a true halftone, but gives the effect greater impact.

Images or type can even be used to make halftone dots. The size of the dot is governed by the resolution of the image chosen to create it. For example, if the image to be "halftoned" is 300dpi and you want a halftone of 10 dots per inch, then by dividing 300 by 10 gives you a resolution for the "dot" file of 30dpi. This file is then saved as a pattern (Edit > Define Pattern), and given an appropriate name.

Make a duplicate layer of your original image, and make the new layer "Grayscale." Create a new layer in your original image and choose Edit > Fill, selecting the new pattern from the pull-down menu. Choose Image > Apply image to combine the pattern layer with the gray layer, and change the blend mode to Overlay.

Right: A dot pattern made simply with the letter "X."

Far right: The original image of the rose has been used to create a halftone dot "pattern" in Photoshop. The halftone image produced takes on the characteristics and colors of the original.

Fruit, sliced thinly, placed directly on the scanner's glass, and scanned in "transparency" mode. The background has been added using image editing software by selecting areas with a magic wand tool and filling with the desired color. The overall image has been softened using a "Median" filter to remove the hard-edged photographic effect.

5.2

Input devices > **Scanning**

The scanner is commonplace both in the office and as part of a work-at-home set-up, but it is often overlooked as a creative tool. Like the office photocopier, a scanner can be used to capture not only documents and photographs, but also objects. Remember when you first placed your hand on a photocopier and were amazed that you had taken a "photograph" of your palm?

There are all sorts of creative opportunities open to the digital artist by thinking slightly "off-the-wall." You can scan natural objects, such as flowers and leaves, using both reflective and transmissive modes for different effects. You can create textures by scanning objects with unusual surfaces, pieces of wood or rusted metal, or even a handful of sand or gravel (on a sheet of acetate). A glass container filled with colored water, a pile of assorted coins or buttons, or even rubber bands...Once you let your imagination go, the possibilities are endless.

To achieve an optimum result, there are a few technical observations that should be taken into account when performing a scan. The maximum frequency, or resolution in terms of lines per inch, that can be sampled by the scanner is known as the Nyquist Frequency. Essentially this frequency is half the sampling rate of the device. If your scanner has an optical resolution of 600 pixels per inch, then the maximum amount of detail it can capture is 300 (horizontal or vertical) lines per inch. This calculation applies to line artwork.

For color imagery, such as a photographic slide, you would need to scan at up to three times the resolution of the film to be sure of capturing all the available color information.

You should also be aware of the relationship between the scan resolution and the size of the final output. This is generally not an issue if the final image is only to be viewed on screen at a resolution of 72dpi. However, if you intend to output the image to a CMYK printing press, a low resolution scan can look disastrous.

If you perform a scan of a printed image from a magazine or newspaper, which is composed of halftone dots, the result is likely to suffer from an effect known as moiré, where the pixel arrangement reacts with the dots to form lined patterns. Some scanning software includes a "descreen" option that has the effect of softening the detail to reduce the moiré.

A scanner's resolution is often quoted by two figures, for example 1200 x 6400dpi. The first figure refers to the maximum optical resolution, or the number of pixels per inch the machine can actually scan. The second figure relates to the "interpolation." This is a software based technique of adding similar colored pixels to an image where none exist, to soften the effects of pixelation. Unless a blurring of the image is deliberately wanted to help an artistic effect, or jagged edges softened for a clearer presentation of black text, interpolation is probably best avoided.

Most scanning applications have at least three scanning modes. Reflective, transmissive, and negative. Interesting effects can be achieved using any of the variables.

Below left: Here we have scanned in transmissive mode and changed the "Hue / Saturation" levels of the result.

Bottom left: A negative scan has been "inverted."

Below center: A straightforward negative scan.

Bottom center: A reflective scan has had flat color added to the background using a magic wand tool and then the Photoshop "Plastic Wrap" filter applied.

Translucent material, such as patterned glass, can be placed on the scan bed and used as a "screen" to add textural effects.

Below: Decorative glass used with an image torn from a magazine.

Bottom: The object can be moved while scanning. Rotating it gives the illusion of movement.

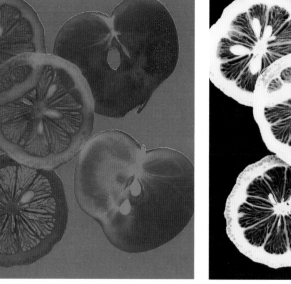

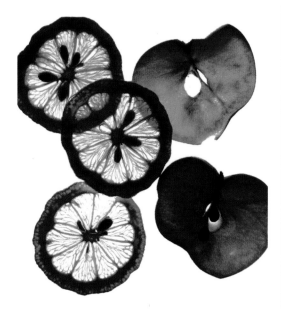

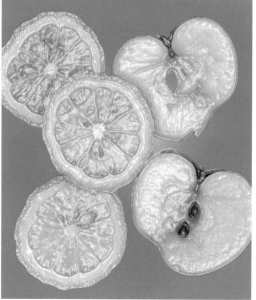

Opposite: Circuit boards scanned in reflective and transmissive modes are placed in a layered file with various blending modes applied to create a "techno" collage. Computer art in a very real sense.

Virtually any object that can be placed on the scanner's glass can be used to create interesting textural images, either in their own right or as a background for other composite images.

Left above: A multitude of miniature plastic marker pens. Similar patterns can be achieved with plastic buttons, cutlery, or "swizzle sticks."

Left below: Linear textures can be provided by scanning wire, string, or even rubber bands. These wires, scanned in negative, have been treated with color overlays and a Diffuse filter.

Far right: To create this "smoke" effect, a glass tray filled with water has been placed on the scanning bed, ink is then randomly dropped into the water and the scan made while the ink dissipates.

Right: Scraps of fabric make excellent source material. Use the weave for texture, or choose patterns or colorful stripes for inspiration.

Right: Metal grills or mesh, such as those used for decorative radiator covers or loudspeaker cabinets.

Far right: Raiding the larder again to scan dried pasta poured directly onto the scan bed. All sorts of foodstuffs can provide the basis for dynamic imagery.

Patterns often benefit from the avoidance of a repetition that is too obvious. By first creating a single element, then copying and flipping it horizontally or vertically to make a combination of four or more elements before applying the repeat, the brain can be fooled into believing a pattern is more complex than it really is.

These images have been created in Photoshop, making full use of vector paths, layers, filters, and blending modes to build the individual elements. They are all based on a linear grid divided into equal square sections, though the final crop has sometimes involved shifting the repeat by half a square in either axis.

5.3

Photo image art > Pattern

"Pattern making" is often frowned upon by serious artists for being frivolous and having no intellectual merit. However, throughout history, encompassing all civilizations, mankind has used symbolism and color to create pattern for both pleasing decoration, and religious and cultural significance.

Pattern bombards us continuously in our everyday lives. We wear it, decorate our artifacts with it, and use it to cover every surface of our homes. Whether we are aware of it or not, pattern plays a significant role in the way we see the world.

The dictionary definition of pattern is "ornamental design," or the recurrence of similar forms at regular intervals. The way in which the similar "motifs" are placed is known as a "repeat." The repeat pattern developed largely due to production or manufacturing restrictions–the width of the loom or the size of the printing press–but the repeat is an important element in the visual complexity of the design. A good pattern always has an underlying symmetry, though sometimes this may be intentionally disguised.

The popular, if short-lived, movement of the mid-1960s known as Op Art, brought us images that fooled the eye and stimulated the senses. Though not created as patterns, this imagery was taken up by the manufacturers of textiles and wallpapers and became part of popular culture. Optical Art is a mathematically themed form of abstract art that uses repetition of simple forms and colors to create vibrating effects, foreground-background confusion, an exaggerated sense of depth, and other visual effects.

Traditionally, designing pattern has been a painstaking process of combining art with mathematical precision. Using the power of the processor, the digital artist can supply the creative input and the machine will do the rest. Repetitive function is fundamental to digital processing, and tools that automatically create pattern are built into most programs. The libraries of backgrounds supplied with Photoshop and Illustrator are simply small patterns that repeat to fill a defined space.

To reduce download time when viewing a web page, HTML code has provided a simple method of filling the web browser window using a "tile," a small repeating element that fills a background starting at the top left corner and proceeding across and down. ImageReady, the web creation software shipped with Photoshop, includes a "Tile Maker" plug-in that can also be used within the main application to do just this.

Even though the digital tools are readily available, creating a convincing repeat pattern is a skill–the interaction of the form and color of the elements can make or break a final design. There is a fine line between art and a confused mess.

The advantages of using the computer to create pattern extend far beyond tiling or mathematically generated repeats. Textures, or "Mosaics," can be built using photographic imagery by simply using keystrokes. In these examples, a small section of an image of a flower—either the bloom, or a collection of blooms and leaves—has been "cut-out" of the original image by carefully drawing around the selected elements with a vector path tool,

choosing Paths > Make Selection, and copying the selection to a new layer. You are given the option to make a "Feather Radius" when you make the copy. This softens the edge of the selection by a fixed number of pixels (0.5 or 1 is usually enough to make the composite look less contrived). The new layer can now be duplicated as many times as necessary and the individual elements randomly positioned to fill the required area.

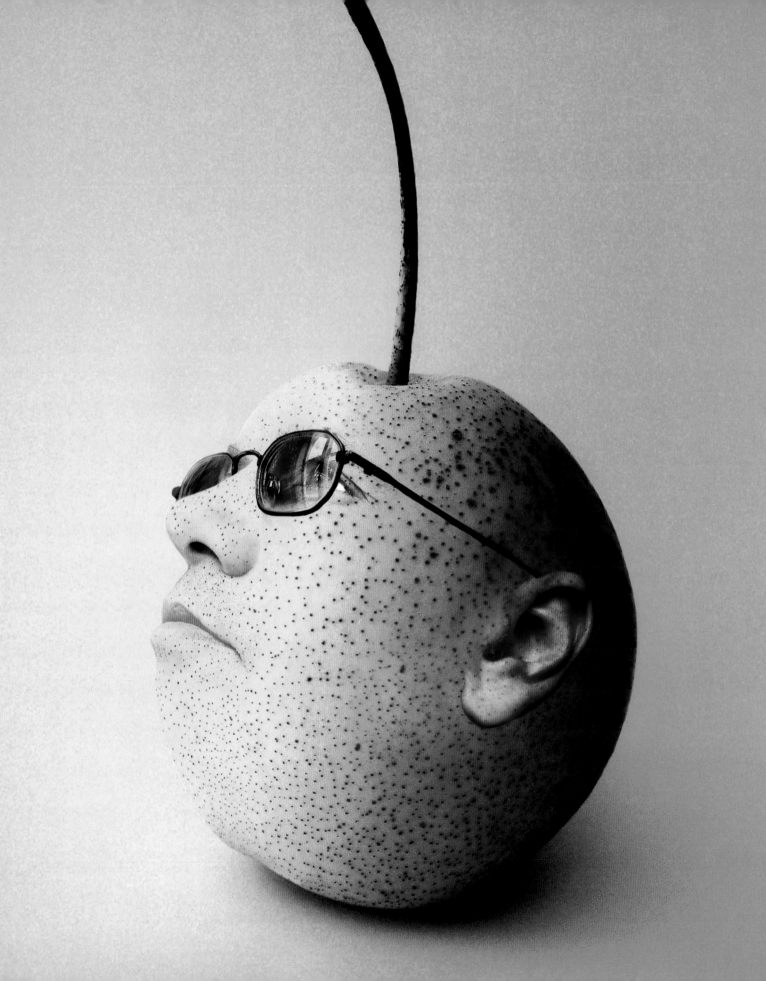

Left: Two photographs make up this composite image entitled "Pearhead," and created by photographer Barry Jackson: The pear itself, which is a carefully lit studio shot, and the side-on view of the face whose features are superimposed onto the pear.

Right: The image of the pear forms the background layer, and sits at the bottom of the stack. A copy is made of the layer containing the face, and it is resized to fit. The background and everything but the glasses and key facial features are then erased.

5.4

Photo image art > Montage

Traditionally, a "photomontage" is a method of superimposing several photographic negatives to make a single mechanical print. A "collage" is the assembly of several photographic images mounted together, sometimes incorporating non-photographic elements. Using Photoshop, the distinction between the two styles breaks down. Layers in a single Photoshop document may contain photos, illustrations, painting, type, or graphics, and are digitally combined into one image without the use of scissors or glue.

The first step is to collect all the elements required to construct the composite image as separate files. The individual images should be adjusted to make sure they are all at the same resolution, otherwise one element may appear hugely out of scale compared to another when copied into the composite image.

Choose your background image and save it as the master file for the composite. Make each image active by opening it onto the desktop and clicking on it, then either select all (Select > Select All), or select the portion you wish to use by utilizing the Lasso or Pen tools to draw around the required area, then copy the selection (Edit > Copy). Make the background, or master, image active, and paste the selection into it. A new layer will be automatically created containing the new pasted selection. The original background layer may not be visible, as it will probably be hidden by the new layer. The layer blending and opacity modes mean the relationship between the different layers can be easily adjusted. By choosing one of the blending modes or changing the opacity of the top layer, you can experiment with individual elements.

Any layer can be moved by selecting it and using the Move tool, or unwanted areas removed with the Eraser tool or the Extract command. The size and shape of individual layers can be altered with the options found under Edit > Transform. The Clone Stamp is useful for copying image material from one part of the composite and repeating it in another area, and selections can be "feathered" to help blend images into one another. The Highlight and Shadow details of separate layers can be manipulated using the Curves and Levels controls, either as a command, or by using a more flexible "Adjustment layer."

If you are combining several photographic images for a realistic effect, it is important to be aware of the direction of the light and shadow in each element. To a certain extent, the effects of light can be altered using the filters, but if the light source is obviously from the right in one image and from the left in another, it can be impossible to change, and will make the combined image look contrived.

Layer "Masks" are useful when creating composite images. Each layer in a Photoshop file, except the "background" at the bottom of the layer stack, can have two kinds of "masks" applied for hiding or revealing parts of the layer without permanently

changing the actual pixels. Rather than erasing or cutting away parts of an image, you can leave it intact, and block areas with a "mask." A Layer mask is a pixel-based grayscale mask that can be shaded from white to black. Where the mask is white, it is transparent and allows the image to show through; where the mask is black, it is opaque and the corresponding area of the image is blocked, or masked. The gray areas are partially transparent–the lighter the gray, the more of the underlying image will show through. The layer mask will only affect the layer it is applied to; it does not mask the layers above and below.

The other form of mask is a vector based path drawn with a pen tool and saved as a "clipping path." Like other vector paths, it can be resized, rotated, skewed, or transformed repeatedly without the deterioration that would occur if you transformed a Layer Mask in the same way. However, as it is vector based, a Clipping Path creates a hard, crisp edge to the selection, allowing no softness or partial transparency to the parts of the layer that it reveals.

Above: *A Sudden Gust of Wind (after Hokusai)*, 1993, by Canadian photographer Jeff Wall. Wall creates his works using actors and actresses on location, as in a movie production, and uses a computer to construct elaborate scenes. Just as painters of past ages composed and depicted historic scenes, landscapes, and fashions, Wall portrays our present age applying his knowledge of art history and photography. This work, which seems to have frozen a scene of a film or a phase of an everyday episode, was influenced by the Japanese woodblock artist, Katsushika Hokusai—a portrait of modern times modeled after *Sunshu Ejiri*, one of *The 36 Views of Mt. Fuji*.

Right: Illustration for the cover of a magazine targeted at visitors to London. A digital "collage" composed from a collection of photographic images of the city, highlighting the attractions and the history. Made in Photoshop using layers, layer masks, and blending modes.

Masters of the art > Steve Caplin

Steve Caplin is a freelance photomontage artist specializing in satirical illustrations for British national newspapers. He's also a beta tester for Adobe Systems, a Contributing Editor to *MacUser* magazine, and the author of numerous design books, including the best-selling *How to Cheat in Photoshop*.

Above: An image for *The Guardian*'s *Weekend* magazine, about the Bush family at Christmas. "With these cast-of-thousands illustrations, it's always tricky to make the characters look as if they are interacting with each other; fitting seven people (and a turkey) into a scene without making it look too overcrowded takes a lot of juggling of layers."

Above right: A montage for the front of the G2 section of *The Guardian*, for a story on whether the British have lost their sense of humor. "The hard part here was assembling the main figure (based on Britannia): it's hard to find pictures of women in white dresses sitting down, viewed from the side! But the comic elements worked well for me, and it made an impressive cover."

Left: "This illustration was for the *Independent on Sunday*, for a story about how bankers are overrun with red tape and regulations. For historical reasons, newspapers still pay less for mono illustrations than color ones—even though, in photomontage terms, mono is very much harder to create. The tiny men were all modeled in Poser, which gave them an unreal quality that suited their uniform, faceless nature."

Above: "A front cover illustration for *The Guardian* media section, about Disney boss Michael Eisner's troubles with the board. The rollercoaster cart was modeled in Adobe Dimensions, a now ancient modeling program that had the ability to export 3D models as scalable EPS files. It wasn't sophisticated, but it was the best solution for creating quick perspective models that could then be fine-tuned in Photoshop."

The Trace Contour filter looks at relative brightness levels of the image, and surrounds similar areas with a one-pixel-wide line. Here, the original background layer has been duplicated twice, and each layer treated with the filter at different edge values (200, 100, and 50). The layer blend in the top two layers has been changed to Linear Burn. The image has finally been flattened and the first two filters in the Stylize suite applied—Diffuse, with Anisotropic selected to soften the lines a little, followed by Emboss at maximum height and amount.

5.6

Photoshop > **Filter effects**

The Photoshop filters menu is packed with a collection of 109 filters from which to choose. The majority of these filters offer "artistic" enhancements that take the form of painterly or graphic simulations, texture effects and distortions. Surprisingly, the group designed to deal with correcting flaws in the photographic original is much smaller.

The filters are grouped into sections that roughly relate to their purpose, such as Blur or Distort, and groups can be selected to automatically open in a Filter Gallery window. The Filter Gallery allows you to see the effect of two or more filters simultaneously. By clicking on the turned-page icon at the bottom-right of the Gallery, the first filter you chose is duplicated, click on another filter to change it. Using the "eyeball" icon will show or hide the effect of each filter. You can add and sample over 100 filter layers, but, in practical terms, four different filters are already overkill. In some cases, there are more effective ways of achieving a filter's named objective without using the filter at all.

Even if your final output is destined to be a CMYK printing press, the creative filter work should be done with an RGB file, and the conversion made once you are satisfied with the result. The reason for this is that all the filters operate in RGB, but many of the most creative groups are eliminated in other color modes.

You can reduce a filter's effect by choosing Edit > Fade immediately after running the filter. This has the same effect as if you had applied the filter to a new layer above the original and were reducing the layer's opacity. The Fade control also allows you to change the blending mode.

The digital artist should beware of being seduced by the obviously artistic sets of filters, namely; Artistic, Brush Strokes, and Sketch. These filters generally attempt to simulate various traditional painting and drawing techniques, and, though they might be fun to play with, making a photograph look like a painting is not creating true digital art. There are a few exceptions hidden away in these sets; Neon Glow, for example, usually rejected by Photographers, can produce some interesting non-painterly results.

Selecting a photographic image as your starting point, the filters can perform total transformations. Used in conjunction with the color adjustment tools, such as Hue and Saturation, very nonphotographic abstract results can be achieved. Using the filters at extreme settings can produce some interesting and unexpected effects. With such a large number of available filters, and uncountable combinations of adjustments, the possibilities for experimentation are just about endless.

Below left: **An almost scientific abstract can be achieved by firstly softening the detail of the image using the Noise > Median filter, followed by alternate applications of the Image > Adjustments > Hue/Saturation and Brightness/ Contrast commands,** increasing the saturation and contrast until areas of strong flat color are formed. Any resulting jagged edges can be softened by a minimal application of the Blur > Gaussian Blur filter.

Below: The same image treated in a totally different way. Again, the Noise > Median filter was used to soften the photographic detail, and the color saturation reduced to create a more monochromatic effect. The Watercolor filter was then applied from the Artistic suite to produce this subtle, but powerful result that does not suffer from being too obviously "painted."

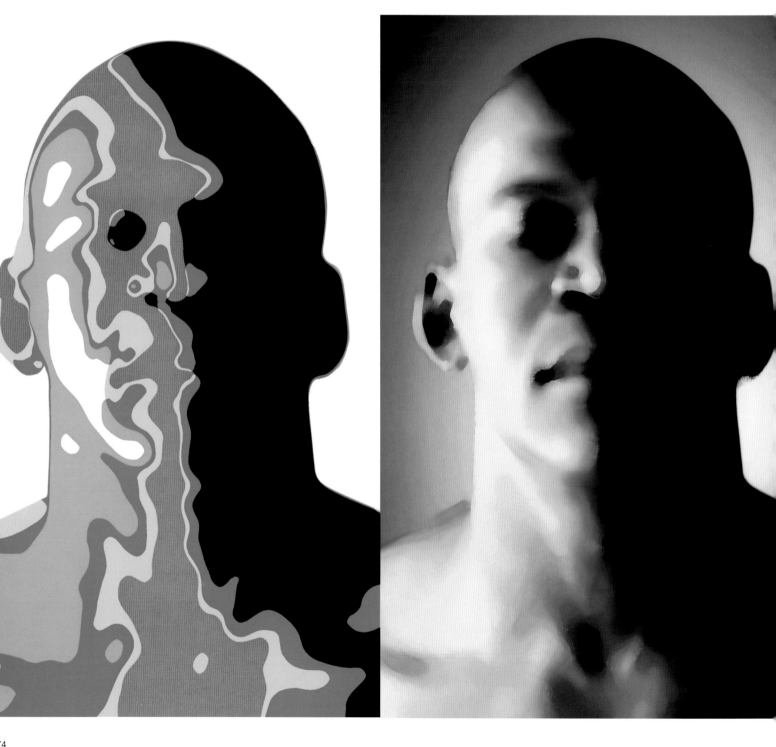

Neon Glow, found in the Artistic suite, requires a two-step approach. If the filter is applied when the Color palette is set to the default black/white, the whole image, except the highlights, is reduced to gray. A "Glow Color" panel gives access to the Color Picker, where you can choose a color to influence the highlights. For more interesting colorful effects, the foreground color needs to be changed before running the filter. The gray image will be colorized by your color choice. With the filter dialog box open, select a contrasting glow color for the highlights. The intensity of the highlight can be varied to change the balance between the two colors.

Left: It's hard to imagine that a photograph had anything to do with this abstraction. The Pixelate > Pointillize filter has been applied using a "Cell" size of 80. It makes little difference what original subject matter is used, the important factor is the relationship of the colors. The exaggerated Pointillize effect makes its own new dynamic forms.

Top: An ethereal image created by judicious use of the Blur > Radial Blur "Zoom" filter, and Render > Lighting Effects and Lens Flare filters. Lighting Effects contains a useful collection of variables and controls. Lens Flare, on the other hand, is generally overused by photographers wanting to spike up a flat exterior composition.

Above: Render > Difference Clouds is another filter that requires setting the foreground and background colors in the color palette before application. Red and yellow were chosen to colorize this picture of autumn leaves on a pond.

Top: This aerial "cityscape" was created by applying the Extrude filter, which divides an image into squares and then extrudes (pulls out) these squares to form 3D columns. The columns can either be capped with the original image, or a solid color based on the average color of the pixels of that square. The sides of the columns are always made up of solid color. The columns extend out as if from a sphere, so the more peripheral columns are at more of an angle to the viewer.

Above: A symmetrical form made by first applying the Pixelate > Crystallize filter to a photograph that started life as a Duotone (a grayscale image with another color added to give more tonal depth). The result was duplicated a further three times, each layer flipped horizontally or vertically, and combined to accidentally create "the alien."

177

Left: The ZigZag filter can be used to create convincing liquid effects. The original shot of a swimming pool has been treated with the Pond Ripple option.

Below: The Wave filter control panel contains seven sliders, three choices of waveform, and a Randomize function. The number of generators has a huge effect on the result. To achieve a controlled distortion, start with just one generator and then incrementally increase the number to see the effect before experimenting with higher values. This organic image started life as a bowl of tomatoes.

Right: Liquify is another complex filter. Like the Warp control, the distortion is based on a mesh, or grid. With Warp you distort the mesh by grabbing handles at each intersection point, Liquify uses a variable sized "brush" to drag areas of the mesh by hand. There are 12 functions in the toolbox to adjust the levels of distortion with familiar names to users of Adobe applications, including Twirl, Bloat and Pucker, and a masking option that allows you to protect areas of the image from the warp effects.

When you warp a bitmap image, the image becomes slightly less sharp each time you commit a transformation; therefore, performing multiple commands before applying the cumulative transformation is preferable to applying each transformation separately.

Part 6

output and presentation >

"KimChants"

Copyright © Mark Chalon Smith

annette Jacobs

Digital Art Gallery

MESART

Community				
Support				
About Us				
Services	Sign Up	Member Login	Newsletter	Power Search
BUY ART	FINE ART	CRAFT	GRAPHIC DESIGN	Artist Listing

Bruce Hopkins
Space-1-#2A
Digital/Graphics

Artist's Information
Contact info

Artwork Description

Digital giclee print in an edition of 25. As it is digitally created vector art it can be scaled and printed in various sizes up to 5' wide. Price is based on size. Available unframed only. Prints are produced on demand. Contact the artist or more information. bruce@bkhopkins.com

Send

Gumbo autoplay

<< 1 2 3 4 5 6 7 8 9 10 11 12 >>

182

Left: Some promotional websites dedicated to digital art. Sites can be setup by individual artists to act as a showcase for their work, or by commercial online galleries. These accept work for presentation from a number of artists and take care of the e-commerce minefield, taking a percentage of the sale for their efforts.

6.1

Staying virtual > Using the Internet

Creating your own website and publishing your work online will give you the opportunity to reach the widest possible audience. If your interest goes no further than giving friends and family the chance to see what you are capable of, then this is a fairly straightforward process. If, however, you think that your endeavors warrant commercial status and that you might be able to make some financial return, then things are a little more complicated.

To simply view images online, without the need to print out hard copy, the file sizes can remain small; you never need to supply a resolution of more than 72ppi, with physical dimensions that can be easily viewed on an average monitor, which these days is 17 inches. This means the time involved in posting the images to your site, and for the viewer to open them, will be relatively small (depending on your connection speeds). The most widely used file format for saving and transmitting images digitally is JPEG (see page 48). If you want to sell the images, however, you will need to offer a higher resolution option to give the purchaser the opportunity to print a high-quality copy. This will involve much larger file sizes, and consequently you will need more available web space to store them.

If the site is to be commercial, there are other issues to bear in mind. Firstly, you don't want it to look too home-made; it should be professional and well designed, a place that people will want to return to, with a simple "interface" that makes it easy to navigate and view individual works. Depending on how many images you are offering, they may require grouping into categories of style or subject matter. Remember that you only want to provide access to a high-resolution file once payment has been received. If you are not familiar with web creation software, it is advisable to seek professional advice or employ a specialist web designer to create the site for you.

More difficult, if financial transactions are to be performed, is the issue of security. You will need to organise a secure method for prospective buyers to make payments, and feel confident when doing so. There are a number of reputable online services that can set this up and give advice, such as www.paypal.com. Your banking service may also be able to assist. It is very important to get this information so you understand both your legal rights as a vendor, and the rights of the purchaser.

Copyright laws apply to work published on the Internet in the same way as any other medium. These laws are extremely complex, and there will always be a certain amount of risk involved when putting your work on the Web. As a basic precaution, you should include a copyright notification with your name, date, and an "all rights reserved" message on every page, with a link to a full copyright statement.

Left: **If you want to use the Internet for transmitting imagery, or uploading to a website, you are going to need a high-speed DSL, ISDN, or cable connection. You will then require an FTP client to make life easier. CuteFTP for Windows, or Fetch or Captain FTP (pictured) for Mac OS are useful applications. The communication process between your computer and a host FTP server is controlled by icons and buttons, and once connected, file transfer can be performed by "drag and drop."**

Right: **www.vladstudio.com is an enterprising site offering digital art for use as desktop "wallpaper." To download high resolution images to fit your particular screen, you are required to register to the site by making a small subscription payment. This particular site also includes a step-by-step tutorial explaining how you can create your own images using Photoshop.**

An alternative way to get your creative output in front of a receptive (computer-based) audience, is to offer your images as desktop "wallpaper." Once the wallpaper has been downloaded by the recipient, it can be placed in the required folder in the computer's system, and set as the default desktop image. This means that while the machine is running, your creation will be permanently on view. You could even make a small charge for the service. To make it as easy as possible for the prospective purchaser, you will need to offer a selection of file sizes and resolutions to suit all the common sizes of monitor, ranging from 800 x 600 pixels to 1280 x 1024 pixels in both standard and wide-screen formats. Look at your monitor setup control panel to see all the possible permutations.

> Getting noticed

To get your site seen by the maximum number of people, it needs to be recognized and listed by search engines. Search engines use a software "spider" or "crawler" to read every site published in cyberspace, and follow links to other pages on the site. The information found goes into the engine's index, but due to the vast and complex composition of the Internet, this can take several weeks.

It is in your interest to make your site as search engine-friendly as possible, and there are a number of ways to achieve this. META tags are words or phrases entered into the HEAD content of the site's HTML code to provide the search engine with a keyword or abbreviated description to associate with your page. Judicial use of keywords is recommended; if the search engine reads obvious repetition of the same word, your site could be ignored or even "blacklisted." Strategic keywords are relevant words that should appear in the title, page headline, body copy, or META tags to make recognition of your site's content as easy as possible to the "spider."

The simpler the construction of the site, the easier it is for the search engine to read it. By the nature of its content, your site will be very image-heavy, which is often a disadvantage in itself when it comes to upload and download time, but a complex site constructed using Macromedia Flash or with "frames" will be unreadable by the search engine, so should be avoided.

To give yourself a fighting chance of being listed by as many search engines as possible, you should take the time to manually submit your site to each of them. This may involve filling in a short form for each, containing the URL and any comments you may want to include. There are many free online services that will take some of the drudgery out of this task.

Right: Several web servers offer free storage space. Most have a limit on how much data you can store and how much you can transfer in a day without incurring charges. The Apple iDisk offers 250Mb of space for an annual fee, and access can be gained from any computer with an Internet connection.

6.2

Presentation > **Backing up**

One of the drawbacks when creating art digitally is that graphic files tend to be very large, especially if you are working with highly complex layered documents. All these files need to be stored somewhere, and the capacity of most built-in hard drives is limited. Even if you don't intend to use a web site to display or sell your work, the Internet provides a capacity for you to store your files. Many web servers now offer free space, mainly aimed at the computer user who can't afford to buy stand alone large capacity back-up hardware.

It is essential to keep a copy or "back-up" somewhere other than your computer's hard drive. Though the latest machines are fairly stable, crashes can always occur, and there is nothing more frustrating than losing your work due to a system failure. Most machines now come equipped with a built-in DVD writer, so if you don't possess a separate hard drive, get into the habit of regularly writing your work to disc.

6.3

Presentation > **Printing and displaying**

Thanks to the advent of affordable desktop printers, and fine art papers available in different surface finishes to go along with them, most examples of digital art are printed at 11 x 17 inches, known as tabloid.

The simplest way to make your art stand out from the crowd is to present it in another format, and recently there has been a growth in the number of companies offering reasonably priced large format prints of 20 x 30 inches or more. It is now even possible to produce "digital wallpaper"–prints large enough to cover the wall of an entire room from ceiling to floor. As previously mentioned, image resolution is an issue when printing at a larger size, but generally the impact of a huge print, normally viewed at distance, outweighs any softening of edge detail that can only be seen under close scrutiny.

You might also want to think beyond paper. You can print images on many types of media; canvas, silk, light and heavy cottons, or polyesters as long and as wide as you need. Some digital artists print on clear or opaque acetate, which can then be back-lit like a large photographic transparency to mimic the effect of a computer monitor.

Don't forget that to achieve the best color results from most printing devices, the image file should be converted from onscreen RGB to CMYK color mode (see page 50).

Mounting and framing a digital print gives it substance and authority. There are many interesting ways to frame your art that might be more appropriate to the technologically generated subject matter than by simply adding a metal or wooden border. Creative use of Plexiglas–for example, to hold the artwork in a transparent "box" and avoid a defined framed edge–can give a flat printed image a more substantial three-dimensional appearance. Printed work can be mounted onto a thick wooden board and covered in a gloss or matt lamination film to protect it. Rather than adding a separate frame, the edges of the print can be wrapped around the mount board.

Digital art can now be found displayed in galleries and museums, often incorporating innovative framing. It's worth spending time visiting exhibitions, not only to see what can be achieved creatively, but to get inspiration for framing and presentation. No matter how well an image works on screen, a professionally presented "hard copy" can ultimately make all the difference.

Glossary

additive colors The color model describing the primary colors of transmitted light: red, green, and blue (RGB). Additive colors can be mixed to form all other colors in photographic reproduction and computer display monitors.

alpha channel A place where information regarding the transparency of a pixel is kept. In image files this is a separate channel—additional to the color channels—where "masks" are stored.

anti-aliasing A technique of optically eliminating the jagged effect of bitmapped images or text reproduced on low-resolution devices, such as monitors. This is achieved by blending the color at the edges of the object with its background by averaging the density of the range of pixels involved.

ASCII Acronym for the American Standard Code for Information Interchange, a code that assigns a number to the 256 letters, numbers, and symbols (including carriage returns and tabs) that can be typed on a keyboard. ASCII is the cross-platform, computer-industry standard, text-only file format.

bitmapped graphic An image made up of dots or pixels, and usually generated by paint or image-editing applications, as distinct from vector images.

blue One of the three additive colors (red, green, and blue).

calibration The process of adjusting a machine or item of hardware to conform to a known scale or standard so that it performs more accurately.

CMYK (cyan, magenta, yellow, and black) The four printing-process colors based on the subtractive color model (black is represented by the letter K, which stands for key plate). In color reproduction, most of the colors are achieved by cyan, magenta, and yellow; the theory being that when all three are combined, they produce black. However, this is rarely achievable—and would be undesirable as too much ink would be used, causing problems with drying time, etc. For this reason, black is used to add density to darker areas—while, to compensate, smaller amounts of the other colors are used (this also has cost benefits, as black is cheaper than colored inks).

color picker A color model displayed on a computer monitor. Color pickers may be specific to an application, such as Adobe Photoshop, or to a third-party color model, such as PANTONE, or to the operating system running on your computer.

cyan (c) With magenta and yellow, one of the three subtractive primaries and one of the three process colors used in four-color printing. Sometimes referred to as process blue.

descreen(ing) The technique of removing a halftone dot pattern from an image to avoid an undesirable moiré pattern occurring when a new halftone screen is applied.

dots per inch (dpi) A unit of measurement used to represent the resolution of devices such as printers and imagesetters; and also (erroneously) of monitors and images, whose resolution should more properly be expressed in pixels per inch (ppi). The closer the dots or pixels (i.e., the more there are to an inch), the better the quality. Typical resolutions are 72ppi for a monitor, 300dpi for a printer, and 2450dpi (or more) for an imagesetter.

EPS (encapsulated PostScript) A standard graphics file format used primarily for storing vector graphics files generated by "drawing applications" such as Adobe Illustrator and Macromedia FreeHand. An EPS file usually has two parts: one containing the PostScript code that tells the printer how to print the image, the other an onscreen preview, which can be in PICT, TIFF, or JPEG formats.

fill In graphics applications, the content, such as color, tone, or pattern, applied to the inside of a shape, including type characters.

four-color process Any printing process used to reproduce full-color images that have been separated into the three basic "process" colors (cyan, magenta, and yellow), with the fourth color (black) added for extra density.

GIF (graphic interchange format) A bitmapped graphics format originally devised by CompuServe, an Internet service provider (now part of AOL). There are two specifications: GIF87a and, more recently, GIF89a, the latter providing additional features such as transparent backgrounds. The GIF format uses a lossless compression technique and thus does not squeeze files as much as the JPEG format. For use in web browsers, JPEG is the format of choice for tone images such as photographs, whereas GIF is more suitable for line images and other graphics, such as text.

grayscale The rendering of an image in a range of grays from white to black.

green One of the three additive colors (red, green, and blue).

HTML (Hypertext Markup Language) A text-based page-description language (PDL) used to format documents published on the World Wide Web, and which can be viewed with a web browser.

interpolation A calculation used to estimate unknown values that fall between known ones. One use of this process is to redefine pixels in bitmapped images after they have been modified in some way—for instance, when an image is resized (called "resampling")

or rotated, or if color corrections have been made. In such cases, the program makes estimates from the known values of other pixels lying in the same or similar ranges. Interpolation is also used by some scanning and image-manipulation software to enhance the resolution of images that have been scanned at low resolution. Some applications allow you to choose an interpolation method—Photoshop, for example, offers Nearest Neighbor (for fast but imprecise results, which may produce jagged effects), Bilinear (for medium-quality results), and Bicubic (for smooth and precise results, but with slower performance).

JPEG/JPG (Joint Photographic Experts Group) A lossy compressed file format in which the degree of compression from high compression/low quality to low compression/high quality can be defined by the user. This makes the format doubly suitable for images that are to be used either for print reproduction or for transmitting across networks, such as the Internet.

K, k (key plate) The black printing plate in four-color process printing, though the name is now more commonly used as shorthand for process black.

layer A level to which you can consign an element of the design you are working on. Selected layers may be active (meaning you can work on them) or inactive.

lossless compression Methods of file compression in which no data is lost (as opposed to lossy compression). Both LZW and GIF are lossless-compression formats.

lossy compression Methods of file compression in which some data may be irretrievably lost during compression (as opposed to lossless compression). JPEG is a lossy format.

magenta (m) With cyan and yellow, one of the three subtractive primaries, and a process color used in four-color printing. Sometimes called process red.

pixel Acronym for picture element. The smallest component of a digitally generated image, such as a single dot of light on a computer monitor. In its simplest form, one pixel corresponds to a single bit: 0 = off and 1 = on. In color and grayscale images or monitors, a single pixel may correspond to several bits: an 8-bit pixel, for example, can be displayed in any of 256 colors (the total number of different configurations that can be achieved by eight 0s and 1s).

plug-in A third-party filter or subprogram that supplements a host application.

PNG (portable network graphic) A file format for images used on the Web that provides 10–30% lossless compression, and supports variable transparency through alpha channels, cross-platform control of image brightness, and interlacing.

PostScript Page-description language. PostScript code tells an output device how to construct page elements.

RGB (red, green, blue) The primary colors of the "additive" color model—used in video technology (including computer monitors) and also for graphics (for the Web and multimedia, for example) that will not ultimately be printed by the four-color (CMYK) process method.

red One of the three additive primary colors (red, green, and blue).

RIP (Raster Imaging Processor) A device that converts page-description data (e.g., PostScript) into a form for output to an imagesetter.

screen capture A "snapshot" of part or all of a monitor display. Also called a "screen shot," "screen grab," or "screen dump."

subtractive colors The color model describing the primary colors of reflected light: cyan, magenta, and yellow (CMY). Subtractive colors form the basis for printed process colors.

TIFF, TIF (tagged image file format) A standard and popular graphics file format—originally developed by Aldus (now merged with Adobe) and Microsoft—that is used for scanned high-resolution bitmapped images, and for color separations. The TIFF format can be used for black-and-white, grayscale, and color images

that have been generated on different computer platforms.

tint The resulting shade when white is added to a solid color.

unsharp mask (USM) A traditional film-compositing technique used to "sharpen" an image. This can also be achieved digitally—by means of image-editing applications that use filters to enhance the details in a scanned image by increasing the contrast of pixels (the exact amount depending on various criteria such as the "threshold" specified and the radius of the area around each pixel).

vector graphics A graphics file that uses mathematical descriptions of lines, curves, and angles. When using vector graphics, it does not matter how large or small you print the file, it will still reproduce perfectly because there are no bitmapped pixels.

yellow (y) With cyan and magenta, one of the three subtractive primaries, and one of the three process colors used in four-color printing. Sometimes called process yellow.

Index

Acknowledgments

The author would like to thank the artists who kindly contributed their work. A special thanks to Chuck Csuri for his time spent finding and photographing examples of his early creations and for his interest in the project. To John Maeda for his immediate response to requests and his inspiration, and to Daniela for her patience and support.

Picture Acknowledgments

6–9 Malcolm Garrett

12–13 Charles Csuri

18–21 John Maeda

28 Patri Feher

29 Tom Fraser/Adam Banks

30–31 Apple Computer, Inc and Microsoft Corporation

34 Apple Computer, Inc

52–53 Charles Csuri

56 Derek Lea

72–73 Alastair Campbell

80 Reinhard Claus

84 René Hernandez Miranda

85 Gary Lucken

86 From top to bottom, Barry G. Rijkse (PixelDam Administrator,
 www.pixeldam.net), Eboy, Gary Lucken

87 Gary Lucken

114–115 Ken Jokol (www.peopleofthefuture.com)

116–117 Brendan Dawes

117 *Hero* images © Beijing New Picture Film Co./Elite Group Enterprises

121 123 klan

122–123 Marius Watz

145 John Maeda

148–149 Benjamin Fry

166–167 Barry Jackson

168 Jeff Wall

170–171 Steve Caplin

172 Photos.com